Photographs from the
MEMPHIS WORLD

 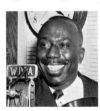

1949-1964

Exhibition organized by Marina Pacini

Photographs from the *Memphis World*, 1949-1964
is published in conjunction with the exhibition, curated by
Marina Pacini.

Memphis Brooks Museum of Art
August 23, 2008 – January 5, 2009
and
Clough Hanson Gallery, Rhodes College
September 5 – October 4, 2008

Copyright © 2008 by the Board of Directors,
Memphis Brooks Museum of Art
All rights reserved.
Distributed by the University Press of Mississippi
Edited: Marina Pacini and David McCarthy
Copy Editor: Carlisle Hacker
Design: Robert Shatzer
Printed and Bound by Paulsen Printing Company, Memphis,
Tennessee, United States

Library of Congress Control Number: 2008928665
ISBN-10: 0-915525-10-0
ISBN-13: 978-0-915525-10-2

Memphis Brooks Museum of Art
1934 Poplar Avenue
Overton Park
Memphis, Tennessee 38104
901.544.6200
www.brooksmuseum.org

Front cover:
Ernest C. Withers, American (1922-2007)
IT'S ALL OVER BUT THE DECISION, 15 January 1958
Silver gelatin print
Memphis Brooks Museum of Art Purchase; funds provided by Sara and
Kevin Adams, Deupree Family Foundation, Henry and Lynne Turley,
Kaywin Feldman and Jim Lutz, and Marina Pacini and David McCarthy
2006.31.49

Inside cover—left to right:
Unknown Artist, American
FLORA FLEMING: QUEEN OF CITY POOLS, det., 25 August 1962
Silver gelatin print
Memphis Brooks Museum of Art Purchase; funds provided by Sara and
Kevin Adams, Deupree Family Foundation, Henry and Lynne Turley,
Kaywin Feldman and Jim Lutz, and Marina Pacini and David McCarthy
2006.31.5

Unknown Artist, American
HE LIVED A GOOD LIFE, det., 20 June 1959
Silver gelatin print
Memphis Brooks Museum of Art Purchase; funds provided by Sara and
Kevin Adams, Deupree Family Foundation, Henry and Lynne Turley,
Kaywin Feldman and Jim Lutz, and Marina Pacini and David McCarthy
RS2006.2.40

Ernest C. Withers, American (1922-2007)
DETECTIVE TURNER NOW A LIEUTENANT, det., 29 August 1964
Silver gelatin print
Memphis Brooks Museum of Art Purchase; funds provided by Sara and
Kevin Adams, Deupree Family Foundation, Henry and Lynne Turley,
Kaywin Feldman and Jim Lutz, and Marina Pacini and David McCarthy
RS2006.2.51

Unknown Artist, American
TOP DISC JOCKEY, det., 4 November 1949
Silver gelatin print
Memphis Brooks Museum of Art Purchase; funds provided by Sara and
Kevin Adams, Deupree Family Foundation, Henry and Lynne Turley,
Kaywin Feldman and Jim Lutz, and Marina Pacini and David McCarthy
2006.31.99

Irving C. Smith, American
FAMOUS PARISIAN MODEL, det., 11 March 1955
Silver gelatin print
Memphis Brooks Museum of Art Purchase; funds provided by Sara and
Kevin Adams, Deupree Family Foundation, Henry and Lynne Turley,
Kaywin Feldman and Jim Lutz, and Marina Pacini and David McCarthy
RS2006.2.37

Opposite page:
Unknown Artist, American
KENNY ELLIOTT: WORLD'S YOUNGEST [NEWSPAPER CARRIER], 15
June 1957
Silver gelatin print
Memphis Brooks Museum of Art Purchase; funds provided by Sara and
Kevin Adams, Deupree Family Foundation, Henry and Lynne Turley,
Kaywin Feldman and Jim Lutz, and Marina Pacini and David McCarthy
2006.31.101

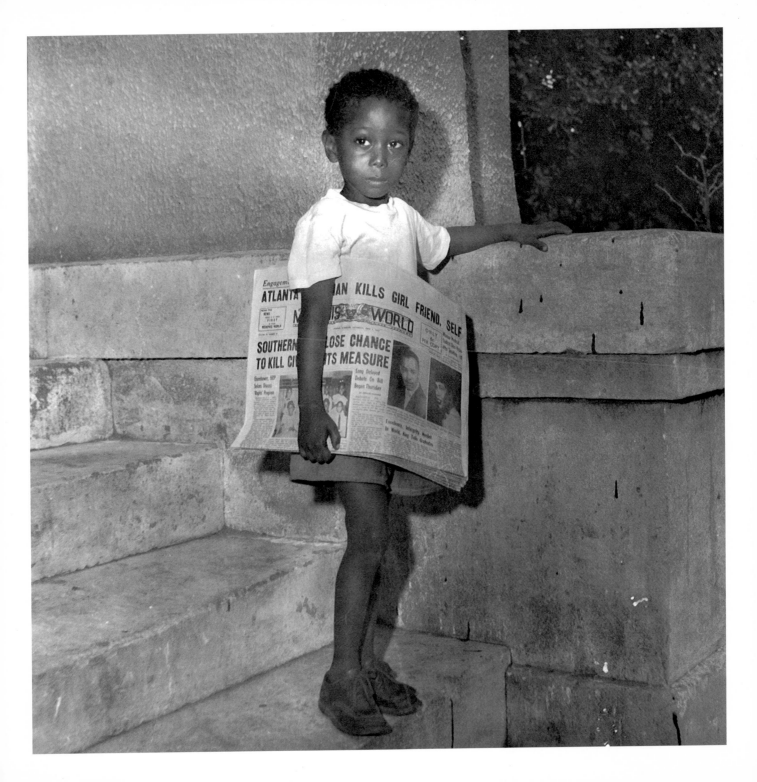

CATALOGUE AUTHORS

Christina Cooke	CC	Katie Selby	KS
Laura Cross	LC	Anthony Siracusa	AS
Amy DeLong	AD	Rachel Touchstone	RT
Katie Duggins	KD	La'Sandria Ward	LW
Amber James	AJ	Elizabeth Welch	EW
Britt Jenkins	BJ	Crystal Windless	CW
Madoline Markham	MM		
David McCarthy	DMcC		
Marina Pacini	MP		

CONTENTS

FOREWORD

The Memphis Brooks Museum of Art enriches the lives of our diverse community through the museum's expanding collection, varied exhibitions, and dynamic programs that reflect the art of world cultures from antiquity to the present. Additionally, we welcome the opportunity to partner with other organizations. These collaborations serve as a forum to introduce new audiences to both institutions. Rhodes College is an ideal choice as a partner because it is also committed to enriching the lives of the community.

These photographs furnish documentary evidence of the everyday lives of African Americans during a tumultuous period of southern history. We are greatly indebted to Professor David McCarthy and his students, who used their research and writing skills to uncover and share a history that is, unfortunately, either unknown or forgotten by many of us. Nonetheless, to know Memphis yesterday is to understand it today, and helps us move toward a better future together.

The photographs are compelling in their own right and need to be shared. This exhibition and catalogue celebrate both the photographers and the events they recorded. The oral history interviews conducted with the sitters and their descendants add a dynamic and important first-person perspective to the project. I am grateful to Marina Pacini and the staff of the Memphis Brooks Museum for undertaking this important project.

Al Lyons
Interim Director
Memphis Brooks Museum of Art

The heart of the Rhodes College vision is to graduate passionate learners and compassionate citizens who become effective leaders in their communities and the world. Rhodes students achieve this vision through rich learning opportunities in the classroom and throughout the broader community under the guidance of talented faculty and strategic partnerships in Memphis. The *Memphis World* catalogue is a wonderful model for college-community collaboration between Rhodes and the Memphis Brooks Museum of Art, a result of which is an inspiring educational piece for all to enjoy. I am grateful to Professor David McCarthy and his students and to our community partner, Marina Pacini, chief curator, as well as the staff of the Memphis Brooks Museum of Art, for producing this fine work.

Dr. William E. Troutt
President
Rhodes College

ACKNOWLEDGMENTS

This project has benefited from the generous support of a very large group of people, from the funders who made the acquisition of the collection possible and the students who researched the images, to the many, many people who assisted with the identification of the sitters and subjects. First and foremost, thanks to Sara and Kevin Adams, the Deupree Family Foundation, Henry and Lynne Turley, and Kaywin Feldman and Jim Lutz, who provided the funding for the acquisition of this important collection for the Memphis Brooks Museum of Art. The exhibition and catalogue have been generously funded by a grant from the State of Tennessee and the Tennessee Arts Commission.

Once the photographs arrived in the building, meetings were organized with community members who helped with the process of identifying the sitters and events in the photographs. The members of the advisory committee were Barbara Andrews, Beverly Bond, Kim Wilson Bond, Phil Dotson, Wayne Dowdy, Ed Frank, Jim Lanier, Marie Milam, Charlie Nelson, Carl Person, Murray Riss, Steve Ross, Joann Self Selvedge, Mark Stansbury, Vasco Smith, and Russell Wigginton. Over the course of the project, other Memphians stepped forward to help, including Barbara Williams and the members of the Elite Club, Dr. Karanja Ajanaku, Debra Nell Brittenum, M.J. Edwards, Doug Halijian, Frankie Jeffries, Nadie Kinnard, Leanne Kleinmann, Andria Lisle, the Memphis Civil Rights Research Consortium, Harold Shaw Jr., Katherine Terrell, Clara Ann Twigg-Mims,

Ronald Walter, Ann Willis, Marc Willis, Miriam DeCosta Willis, and Rosalyn Willis.

Many people agreed to be interviewed for the project and their words contributed significantly to the catalogue. Thanks to Alma Roulhac Booth, Josephine Bridges, Longino Cooke, Justin Ford, Francine Guy, Burnell Hurt, H.T. Lockard, Earline Nelson, Joseph Nelson, Rashad Sharif, Mark Stansbury, Russell Sugarmon, Katheryn Perry Thomas, Emogene Watkins Wilson, and David Wright.

Rhodes College professor David McCarthy, whose idea it was to collaborate on this project, deserves my special thanks. He gave up his summer to teach in the Rhodes College Institute for Regional Studies as a trial run for a seminar he taught in the fall of 2007. His students conducted research and interviewed individuals to produce most of the materials that make up this catalogue. My appreciation goes to Christina Cooke, Laura Cross, Amy DeLong, Katie Duggins, Amber James, Britt Jenkins, Madoline Markham, Katie Selby, Anthony Siracusa, Rachel Touchstone, La'Sandria Ward, Elizabeth Welch, and Crystal Windless. An extra thank-you is due to both Rachel Touchstone and Katie Duggins, who interned at the museum and did a yeoman's job on many other aspects of the project.

All of the authors benefited from generous help from G. Wayne Dowdy and the staff at the Memphis and Shelby County Room of the Benjamin Hooks Library, Memphis. Ed Frank at Special

Collections, the Ned R. McWherter Library, University of Memphis, was also of great assistance.

The other catalogue authors—Dr. Russell Wigginton, Rhodes College, and Dr. Deborah Willis, New York University—helped put these photographs within a national context.

Rhodes College embraced the project from the beginning. Victor Coonin, chair of the Department of Art, and Dr. Charlotte Borst, provost, were enthusiastic early supporters. My thanks to Hamlett Dobbins, Clough-Hanson Gallery director, for exhibiting a selection of the photographs in tandem with the Brooks. Dr. Wigginton, besides writing for the catalogue, consistently provided advice and encouragement. Also from Rhodes, thanks to Dr. Charles McKinney, Suzanne Bonefas, and Katherine Lambert Pennington. The Office of Communications is responsible for the design of the catalogue. Thanks to Daney Kepple, Lynn Conlee, and especially Robert Shatzer for his elegant design.

Thanks to Kevin Barré, who generously made the scans ready for publication, to Carlisle Hacker for copyediting, and to Julie Van Sickel for prepress production.

The staff at the Brooks was a consistent source of support. Kaywin Feldman oversaw the beginning of this project before she left for the Minneapolis Institute of Arts in 2007, and Al Lyons, interim director, capably took up where she left off. Among the many who contributed to making the project a reality are Diane Jalfon and Bob Arnold from development; Claudia Towell, Heather Klein, and Elisabeth Callihan from marketing; and the exhibitions staff: Richard Gamble, Marilyn Masler, Kip Peterson, and Paul Tracy. There are many people in Memphis who talk about the extraordinary staff at the Brooks, but I still think they are among the city's best-kept secrets.

There would not be a project if it were not for the work of the photographers included here. Their skills in composition and storytelling, combined with their obvious connection to their subjects, produced photographs that offered, and continue to offer, a corrective to the segregated history of Memphis. We are all grateful to Bass Photo Co., Clarence Blakely, Coleman Photo Service, P. Cuff, Henry Ford, Hooks Brothers Photography, E.H. Jaffe, Qualls, Reese Studio, Irving C. Smith, Mark Stansbury, Tisby, R. Earl Williams, and Ernest C. Withers.

Lastly, I must once again thank David McCarthy. Besides the enormous amount of time he devoted to his students in the classroom, he spent countless hours researching, writing, interviewing, editing, and promoting the exhibition, not to mention the moral support he gave me that I needed to complete this undertaking in a relatively short period of time. I could not have done it without him.

Marina Pacini
Chief Curator
Memphis Brooks Museum of Art

INTRODUCTION

In the fall of 2006, the Memphis Brooks Museum of Art was approached by a local collector who had some photographs to sell. Although the museum receives many such calls, they rarely concern objects that are appropriate for purchase. This time was different—the collection may be all that remains of the photographic archives of the *Memphis World*, an African American newspaper published in Memphis from 1931 to 1973. Discussions ensued about the possible acquisition, including such questions as: If the museum already has deep holdings of work by Ernest Withers, are more images necessary? Was a selection of mostly unidentified newspaper photographs appropriate for an art museum? Upon examination, it was revealed that besides Withers, at least fifteen other photographers were included, none of whom are represented in the permanent collection. More importantly, even without captions, it was apparent that this was a treasure trove documenting life in Memphis during a crucial period in the city's history.

Through the generosity of Sara and Kevin Adams, the Deupree Family Foundation, Henry and Lynne Turley, and Kaywin Feldman and Jim Lutz, the complete collection was acquired for the museum. In fact, my husband, David McCarthy, professor of art at Rhodes College, and I felt so strongly about the importance of the photographs that we too contributed. As transplanted northeasterners, we have come to love Memphis. A great deal of our admiration stems from the richness of the city's complicated history. In many ways, this history reflects broader trends in the country while nonetheless remaining deeply connected to events and issues intimately tied to the region. Although Memphis lays sad claim to being the place where Dr. Martin Luther King Jr. was assassinated, it is also very well known for the world-famous musical contributions that have poured out of the city. Typically these two subjects receive the most scrutiny, but by no means are they representative of all that is fascinating and worthy of attention. What is remarkable about the photographs from the *Memphis World* is that they clearly and artistically record a compelling and significant period of Memphis history that is unknown to or has been forgotten by many people, whether living here or elsewhere in the United States.

The collection arrived at the museum with little of its history recorded. Jewel Gentry, the paper's society editor and wife of Editor James A. Hulbert, had the complete archive of the newspaper in her possession at the time of her death. Once her estate was settled, all of the materials were put up for sale. The collector who bought these photographs randomly picked through the numerous boxes, selecting what he thought was historically important or visually engaging. It appears this may be the largest group of images from the *World* to survive.

Once the photographs were acquired and the nature of the collection became fully apparent, it was obvious that an exhibition was essential. Having collaborated with David once before on an exhibition when I was director of the Clough-Hanson Gallery at

Rhodes College, I decided to repeat the process. His students from the summer 2007 Rhodes College Institute for Regional Studies and a fall semester seminar would research and write about the photographs for an exhibition that would be mounted both at the Brooks Museum and at Rhodes College in the fall of 2008. From the approximately eighty photographs selected for the exhibition, fifty-seven would be published in a catalogue with essays written by the students, as well as by David and myself.

Most of the images had little in the way of identification: a few had photographers' stamps on the back, a handful had the names of sitters, and the rare example had the publication date noted. The first task was to scroll through the *Memphis World* microfilm at the Memphis Public Library. The collection is incomplete, there are no issues between 1932 and 1943, and in many years anywhere from one to six issues are missing. As there are 222 photographs in the collection, sometimes appearing cropped, it was difficult to find all of them reproduced. We are still reviewing the microfilm for the third, fourth, and fifth time to find some of the as-yet-unidentified images. It was essential, however, that the photograph be found in the paper before it could be considered for the project.

With well over half of the images and their accompanying captions to choose from, the process then turned to selecting what should be included in the exhibition and catalogue. Professional publicity stills of Isaac Hayes and Rufus Thomas were rejected because they were quite distinct from the journalistic or documentary photographs that make up the bulk of the collection. The time frame under review was narrowed down to 1949 to 1964, as this is when most of the images were shot and published. This was also a period in which local white newspapers, by and large, continued to ignore events from black neighborhoods. The importance of African American newspapers in covering the diversity and complexity of black lives is more fully discussed in the excellent and informative essays written by Dr. Deborah Willis and Dr. Russell Wigginton.

Especially fascinating was the transformation that took place either when the photographs were reunited with their captions or when the subjects were researched fully. For example, *Great Leaders* (page 34) captures three men standing on stairs outside a building. It appears to be a conventionally posed image of successful businessmen. What it actually represents is a quiet moment during a heated argument between local leaders and national representatives from the NAACP over the construction of a Negro hospital. The head shot of Lucky Sharpe (page 98) presents something altogether different. His dapper look in a houndstooth jacket was the initial attraction, although the visual appeal was compounded by the fact that the photograph was published at least three times in the paper, suggesting his stature in the community. Much more important than the regularity of his appearance, or his taste in clothes, was the enormous impact he had on the Douglass community during the Great Depression. He organized a community gardening campaign that not only fed the neighborhood residents and schoolchildren, but also helped families stave off home foreclosures, for which he was recognized by First Lady Eleanor Roosevelt.

Many of the photographs revealed similar stories of ingenuity in the face of adversity, or the courage and resourcefulness brought to bear by African Americans in the face of the racism and disenfranchisement they experienced in the Jim Crow South. This is borne out in the oral history interviews conducted with individuals, or their relations, pictured in the photographs. Their stories focus on the fullness of life at the time while noting the indignities routinely experienced—doctors unable to treat their patients at hospitals and women trying on clothes in stockrooms because they were not allowed in changing rooms.

Lest anyone be left with the wrong impression, these images are also a celebration of black life in Memphis: plays, dog shows, tennis matches, fashion, award-winning students, and ground-breaking ceremonies. Even though the collection—and therefore the catalogue and exhibition—is a random selection of photographs, it provides a snapshot of the *Memphis World* and its coverage of education, politics, sports, business, civil rights, the arts, social organizations, society, and religion. What it presents is just a part of the story of Memphis, but it is a story told through engaging and fascinating photographs that leave all of us wanting to see, and know, more.

Marina Pacini
Chief Curator
Memphis Brooks Museum of Art

PHOTOGRAPHING MEMPHIS: THE *MEMPHIS WORLD*

Between the war years, in cities all over America, black newspapers flourished in communities because of the use of photographic images made by local studio photographers and photojournalists. The photograph was used as evidence of an event and was read aesthetically and socially. The black press historicized, celebrated, documented, and reinforced the culture of African American communities by publishing society events, politics, sports, and crime stories. During the late 19th and early 20th centuries, photographs helped to transform the stereotypical images of black Americans ideologically, politically, and aesthetically. As most of these transformed images were of working-class families, community members were enthusiastic about seeing their images published in the local and regional papers. They supported their local photographers, who, encouraged by the numerous requests for photographs, became prominent fixtures on the social circuit. Thus, photographic images housed in black newspaper archives are a paradox as they visualize how power is imagined in racial discourse.

During this period, black photographers illustrated exceptional versatility as they recorded the lives and activities of political leaders, entertainers, and local figures. A unified, progressive black community was depicted as a utopian ideal in black America, and black press photographers portrayed that experience and created distinctive and empowering images of black Americans. Today, their images encourage us to view—and review—black community histories in creative and insightful ways. And, we desire to preserve them. bell hooks believes that "For black folks, the camera provided a means to document a reality that could, if necessary, be packed, stored, moved from place to place. It was documentation that could be shared, passed around. And, ultimately, these images, the worlds they recorded, could be hidden, to be discovered at another time."[1]

The Memphis Brooks Museum of Art's collaboration with Rhodes College is based on the recent acquisition of 222 photographs from the *Memphis World*, an African American newspaper published from 1931 to 1973. This collaborative project is a reinterpretation of the photographs made at a prior time. These images provide a remarkable portrait of African American life in Memphis through the lens of such photographers as Ernest Withers, Mark Stansbury, R. Earl Williams, and Hooks Brothers Photography. Among the themes that will be addressed are education, community, social organizations, civil rights, business, sports, and religion. As in the words of bell hooks, this recent acquisition is being "discovered at another time."

In 1931, J.A. Rogers published *World's Greatest Men of African Descent*; journalist George Schulyer's first novel, *Black No More,* was published; the first "talkie" by a black movie director, Oscar Micheaux, was released; and in Scottsboro, Alabama, nine young men were accused of a crime that caused national attention. It was also the year that the *Memphis World* was introduced as a semiweekly newspaper under the editorial direction of Lewis O. Swingler on June 28. Noliwe Rooks asserts that African American newspapers after the 1880s "functioned as organs of protests" and later at the dawn of the 20th century "[they] focus[ed] stories on individuals that exemplified

racial progress, success, and advancement."[2] In September 1931, the *Memphis World* added a social column. The *World* was modeled after many of the newspapers circulating at that time and promoted that it would provide "news of interest to the race," as well as offering readers "clean and interest-demanding features" that would please "the whole family."[3] The published photographs highlighted the activities of black Memphians. The *World* informed its readers that "The newspaper in your community is the only way in which you can keep informed of local and round-the world happenings. . . ."[4] It also published photographs of club and church events, including beauty contests and award ceremonies. Early on, the *World* emphasized racial pride, economic development, and the accomplishments of black leaders. Readers were informed about events and the importance of Negro History Week. The editor proclaimed the February event "a yearly period which should be observed by every member of the race in America."[5]

In an effort to increase circulation and attract advertisers, in 1938 Lewis Swingler promoted a new campaign for black Memphians. Readers were invited to vote for an honorary Mayor of Beale Street. Matthew Thornton, who was a letter carrier for the post office and a charter member of the Memphis Branch of the NAACP, won with almost 12,000 votes of the 33,000 cast. Thornton held the post until his death in 1963. Beale Street was and still is the central street for black businesses and entertainment.

Between 1913 and 1973 periodicals and newspapers with titles like *Flash!*, *Our World*, *Messenger*, *Opportunity*, *Crisis*, *Bronze*, *Ebony/Jet*, *Silhouette Pictorial*, *Negro Digest*, *Negro World*, *Life*, *Chicago Defender*, *Call & Post*, *Pittsburgh Courier*, the *California Eagle*, *Atlanta Daily World*, *New York Amsterdam News*, *New York Peoples Voice*, *Philadelphia Tribune*, *Afro American*, *Nashville Globe*, and the *Chattanooga Observer* were widely read along with the *Memphis World*. A geographically diverse group of photographers made portraits that were compassionate and terrifying photographs of the harsh realities of the struggle for the right to vote, fair employment, and equal opportunities, in addition to the achievements gained in local communities. Photographers focused on local and national events like the Scottsboro case and *Brown v. Topeka, Kansas Board of Education,* the murder of young Emmett Till, boycotts led by both local citizens and the black clergy, activities of Southern voter registration activists, and the NAACP's Legal Defense Fund. South Carolina-based photographer Cecil Williams recalls, "When I started freelancing for *Jet*, the *Afro-American*, *The Crisis*, and the Associated Press, black weekly newspapers relied heavily on freelancers like myself to cover news from the black perspective because wire news coverage was sparse. . . . As tragic as these circumstances were, it was this background and climate that made me not only a photographer, but a chronicler of the most significant humanitarian movement in the history of humankind."[6]

Whereas a complete history of photography in the black press is still unwritten, this essay offers a link to the history of images published in the aforementioned papers and the recent acquisition of the *Memphis World* photographs. It highlights the cultural and political perspectives the editors and the photographers brought to their work and the individual communities they documented. These photographers knew the significance of their images, as evidenced in their expansive collections. These black press photographers also are linked by their clear understanding that they were recording their distinctive communities, often neglected by the dominant presses. As mentioned earlier, 1931 was a highly charged political time. It also witnessed the Depression, Jim Crow laws, lynchings, and the Migration. Memphis was a community in the midst of transformation, and photographs were crucial; they documented African American achievements as well as despair in a segregated America. This period through the 1960s also witnessed the beginning of the use of handheld cameras and the documentation of public social events. The works of the photographers in this exhibition reveal the photographers' sense of race consciousness, from photographs of Thurgood Marshall; Matthew Thornton Sr., the "Mayor" of Beale Street; Myrlie Evers and her family; Benjamin Hooks; Nat D. Williams; and W.C. Handy. The images presented also include weddings, club-women activities, churches, funerals, tennis players, ministers, school groups, musicians, groundbreaking ceremonies, businessmen, and newsboys. "I find it difficult to look at these photographs without flinching from the memories and from the anger they invoke. But I must look. I must remember, as you must. For this was history in the making. Like it or not, you cannot hide from the camera's eye," Myrlie Evers-Williams observed.[7] These images can be used as a basis for discussion as we begin to carefully reconstruct the period in which they were made.

This overview of the importance of photography in the *Memphis World* also captures the activism of the Memphis community. Many of the photographs published were popular among families and church groups. In 1940, Hooks Brothers Photography was the most sought after black studio in black Memphis. Their insightful photographs reveal

that blacks were active in social events as well as in the local NAACP. They photographed the blues musicians and other entertainers in the area. Brothers Henry A. Hooks and Robert B. Hooks—the uncle and father, respectively, of local civil rights leader and minister Dr. Benjamin Hooks—founded the studio on Main Street. It moved from there to Beale Street years later. After 40 years it moved to Linden Avenue, where the brothers also ran a photography school.[8] In the 1970s, the studio was near Stax Records. As I traveled around the country researching black photographers in the 1980s, I was often reminded that the Hooks Brothers had the oldest black-owned photography studio in the upper Delta region and specifically in Memphis. Their studio was known for its portraits, smiling faces, and posed images of the local community. Over the years, Hooks Brothers Photography, Ernest Withers, and the photographers in this exhibition worked exclusively to increase the visibility of black social life, political events, and everyday experiences also corresponding to the mission of the newspaper.

Memphis-born Ernest Withers (1922-2007) had a few studios in Memphis. As in the case of the Hooks Brothers, he photographed school groups, social events, families, and nightlife in Memphis. In the mid-1950s, he was hired as photographer for the Emmett Till murder trial. The all-white, all-male jury found the white male defendants not guilty.[9] After the trial, Withers returned to Memphis where he copublished and distributed a pamphlet on the murder trial of young Emmett Till, titled *Complete Photo Story of Till Murder Case*. It was sold for $1 a copy. This act revealed Withers' concern for preserving the memory of this horrific experience. As he wrote in the circular, ". . . we are not only depicting the plight of an individual Negro, but rather of life as it affects all Negroes in the United States. . . . In brief we are presenting this photo story not in an attempt to stir up racial animosities or to question the verdict in the Till Murder Case, but in the hope that this booklet might serve to help our nation decide itself to seeing that such incidents need not occur again."[10] Withers's photographs of Dr. Martin Luther King Jr., the sanitation workers strike, and the Lorraine Hotel balcony are often considered sensitive renderings of the events.

Circuit Court Judge D'Army Bailey observed, "We had our portraits made to reinforce our own stereotypes, which were positive. We saw ourselves as sharp. Our shoes were shined, our pants were pressed, and we were very well presented. We had a lot of self-pride, and pictures provided an affirmation of how clean we were in our own mind. We weren't sending messages to white people. We were sending messages to each other, sharing evidence of our vision of ourselves to our friends and family and carrying those visions forward to posterity. Everything critical to our growth and sustenance was supplied by blacks within the black community, and for us, photography provided an extension of ourselves at our best."[11] Withers's photos of lynching victim Emmett Till's bloated body, published in *Jet* magazine, were, Bailey says, "as powerful a voice as any speech Martin Luther King ever gave—a clarion call to black America."

During the Great Depression, photographer Allen Edward Cole posted a sign in front of his studio in Cleveland's Cedar Central community: SOMEBODY, SOMEWHERE, WANTS YOUR PHOTOGRAPH. An entrepreneur with a great understanding for marketing his ideas about visualizing the black experience, Cole stayed active in African American professional leagues and Masonic lodges, and his photographs appeared weekly in the *Call & Post*, a Cleveland black weekly newspaper that published his work well into the 1950s. As in the case of Hooks Brothers Photography and Withers, he was a leading black businessman deeply immersed in civic life. Born in 1893, Allen Edward Cole opened his studio in Cleveland, Ohio, in 1922 and became one of the first black studio photographers in the area. From the early 1920s through the mid-1960s, Cole worked part-time as a photojournalist for the *Call & Post*, the local newspaper, and in doing so, he provided an enduring chronicle of black life in Cleveland for nearly a half century. Like Withers and the Hookses, Cole collaborated with his subjects to articulate a visual form of racial uplift. In his photographs, elegant dignified people in stylish clothes meet his gaze. Group portraits reveal a civic-minded, industrious people, congregating at conventions or commemorating a milestone. Among them are Masons, beauty school students, and insurance sellers, similar to the subjects of some of the works in this exhibition. A signature photograph that features scores of *Call & Post* newsboys—many dressed in period knickers and caps, with a few in aviator hats—is similar to the 1957 photograph of Kenny Elliott holding a stack of *Memphis World* copies. Cole's photojournalism placed him in a tradition of other African American photographers in the 1930s and 1940s who worked for local African American newspapers and national magazines, that were marketed to African American readers.

Living in Chicago in the late 1930s, photojournalist Gordon Parks (1912-2006) had become enraptured with photography at this time.

He viewed a photograph not only as document of an event, but also as art object. He looked for inspiration from art that evoked compassion for the subjects portrayed. Reflectively, Parks writes: "During that first year there [in Chicago] my family learned to spell 'suffer.' But just when food and money hit the zero mark, fate resurrected my hopes. . . . Writers, painters, sculptors and scholars had been recipients of fellowships—but never a photographer."[12] In December 1941, Parks received notice that he was the first photographer to receive a Rosenwald fellowship. It was a historic time. December was the month that Pearl Harbor was attacked; 1941 was the year that Richard Wright wrote *Twelve Million Black Voices*, using Farm Security Administration (FSA) photographs to examine the plight of black life. The fellowship was for $200 a month. Parks chose to work with Roy Stryker at the FSA in Washington, D.C. Parks completed a photo essay on Ella Watson, a charwoman living in Washington, D.C., and later worked for *Life* magazine and traveled the work documenting "life."

Charles "Teenie" Harris was a prolific photographer who during his long life actively published a visual social history of African American life in Pittsburgh. Harris (1908-1998), popularly known as Teenie, was a prominent member of the Hill District in Pittsburgh, where he made major contributions to documentary photography. A self-taught photographer, Harris acquired his first Speed Graphic in 1931. Although he was based in Pittsburgh, he made a series of photographs for a black-owned Washington, D.C.-based weekly news picture magazine, *Flash!* He later worked for the *Pittsburgh Courier*, a national black news weekly, capturing candid poses of celebrities and other sports figures and documenting social and sporting events in the area. He freelanced with them for a number of years and was later hired (in 1936) as the chief photojournalist for the paper. After leaving the *Courier*, he opened Harris Studio on Centre Avenue in the Hill District, but eventually moved the business to his home basement. As in the case of Hooks Brothers Photography and Withers, Harris owned his own portrait studio and documented the realities of segregated cities at mid-century, and his images covered a wide range of subjects, from proud families and protest marches to the social life of black fraternal orders.

The photographs in this catalogue clearly show the social, economic, and political success of these struggling and working-class residents. Black newsmen moved photography from the local community into the national psyche. With the black newspapers and journals publishing black photographers' images, the black photographer emerged as activist and chronicler. The use of smaller hand cameras and faster film stock drastically changed this type of reporting, and eventually these cameras (Speed Graphic, a 4x5 handheld camera that was used by most newspaper photographers during that time, as well as Rolleicord, Crown Graphic, and Leica 35mm cameras) became widely used by photographers covering the marches, rallies, and protesters. Editors of black newspapers and periodicals encouraged photographers to document compelling stories, locally and nationally. Society photographs not only captured the spirit of the moment, but also served as a visual narrative of daily events.

By the mid-1960s, protest movements had become a national crusade for human rights for all oppressed people. Black press photographers were on hand to document these events that impacted the conscience of this country. During this complex period, these photographers sought to create a collective visual memory that would empower Memphis, while at the same time providing evidence of the struggles, defeats, goals, and victories. Maxine Leeds Craig argues that "when social movement leaders use culture as a resource for mobilization, their rhetoric draws on themes that they believe will resonate with their constituencies. . . . Images of beauty and beauty practices can serve as a focal point for the complex project of racial rearticulation."[13] The photographs of the pageants in this exhibition allow the viewer to look critically at the complexities experienced by women, leaders and followers, photographers, and the communities they documented. They also remind us that the photographers in this exhibition played a crucial role by documenting the varied experiences of living in a segregated society and calling upon it to change. The photographs of this era also create a new historical consciousness that had the power to rewrite a visual history. This new visualization depicted images of beauty and work, representing a vibrant community of men, women, and their sons and daughters who fought to achieve their rights. No doubt the studios in Memphis were flooded with requests for studio portraits. This exhibition presents over eighty photographs that form a revised pictorial history of African Americans in Memphis. As Judge Bailey stated, the images in this exhibition celebrated the life of the subjects outside of the stereotype. These images captured a spirit of transformation and empowerment.

Deborah Willis, Ph.D., Chair
Professor of Photography and Imaging
New York University

[1] bell hooks, "In Our Glory: Photography and Black Life," in *Picturing Us: African American Identity in Photography*, ed. Deborah Willis (New York: New Press, 1995), 48.

[2] Noliwe Rooks, *Ladies' Pages: African American Women's Magazines and the Culture That Made Them* (New Brunswick, NJ: Rutgers University Press, 2004), 6.

[3] Roland E. Wolseley, *The Black Press, U.S.A.* (Ames: Iowa State University Press, 1990), 340.

[4] Ibid., 340.

[5] Ibid., 341.

[6] Cecil J. Williams, *Freedom and Justice: Four Decades of the Civil Rights Struggle as Seen by a Black Photographer of the Deep South* (Macon, Georgia: Mercer University Press, 1995), 4.

[7] Myrlie Evers-Williams, foreword to *The Civil Rights Movement: A Photographic History, 1954-68,* by Steven Kasher (New York: Abbeville Press Publishers, 1996), 7.

[8] Pamela Perkins, "Hooks Brothers Photography on Display at Stax Museum," *The Commercial Appeal*, 3 February 2006, B1.

[9] Ernest Withers, *Pictures Tell the Story: Ernest C. Withers Reflections in History* (Norfolk, Virginia: Chrysler Museum of Art, 2000), 60.

[10] Ibid., 60.

[11] Andria Lisle, "Black and White: Three photo exhibits bring the long-hidden world of segregated Memphis to life," *Memphis Flyer*, 16 February 2006, 22.

[12] Gordon Parks, *Voices in the Mirror: An Autobiography* (New York: Doubleday, 1990), 78.

[13] Maxine Leeds Craig, *Ain't I a Beauty Queen? Black Women, Beauty and the Politics of Race* (New York: Oxford University Press, 2002), 14.

THE *MEMPHIS WORLD*: A VOICE FOR EQUALITY

The *Memphis World* newspaper was founded in 1931 by the Southern Newspaper Syndicate. Syndicate owner William Alexander Scott, who had been inspired by Marcus Garvey as a young man, was determined to have a presence of southern black newspapers, published by southern Negroes, to be read by southern Negroes.[1] Thus he founded the *Atlanta World* in 1928 and by 1931 had chosen Memphis and Birmingham, among other cities, as places where a significant black newspaper was needed.

With this goal in mind, choosing to begin another black newspaper in Tennessee and in Memphis in particular made sense. The presence of black newspapers in America can be traced back to the establishment of the *Freedom Journal*, founded in New York City in 1827. The *Journal* focused on northern urban blacks and whites.[2] Black publications began to arise in the South during the Reconstruction era. The first documented black newspaper in Tennessee, the *Colored Tennessean*, published its first edition on 29 April 1865 in Nashville. This early newspaper consistently emphasized race pride, making statements such as "tell us not that we will not work, when it was our toil that enriched the South. . . ."[3] At least twenty-five additional black newspapers in Tennessee were established during the remainder of the 19th century, with all sharing common themes of independence, aspirations, accomplishments, and frustrations of African Americans in Tennessee and throughout the country. In West Tennessee,

specifically, several newspapers were established during this era, including the *Memphis Weekly Planet* (1876), *Watchman* (1878), *Free Speech and Headlight* (1889), *Jackson Afro-American Sentinel* (1890), and *Brownsville Haywood Republican* (1889).[4]

The most widely recognized and influential Memphis black newspaper in the late 19th century was the *Free Speech and Headlight*. This newspaper was published by Rev. Taylor Nightingale, who also served as pastor of the prominent Beale Street Baptist Church. Taylor openly combined religion, business, and politics, as he was unafraid to promote his newspaper from the church and to point out examples of racial injustice in the city. Furthermore, between 1889 and 1892, Taylor's editor for the *Free Speech and Headlight* was activist Ida B. Wells. Described as the "conscience" of the newspaper, Wells was relentless in using her editorials to point out the various ways blacks were exploited in Memphis.[5] But what brought Wells and the *Free Speech and Headlight* national attention was her vivid writings on the horrors of lynching. Wells's written outcry led to the destroying of the *Free Speech and Headlight* offices and intimidation tactics that forced her to leave the city, but not before helping to shape a tradition in which black Memphians would expect black newspapers in Memphis to challenge the status quo.[6]

Albeit with limited success, numerous black newspapers were launched in Memphis through the first few decades of the 20th

century. By the early 1930s, blacks were a substantial percentage of Memphis's population, numbering approximately 100,000 people, and had established a reputation of varied practices in which to combat racial disparities—one of which was through the black press. When the *Memphis World* was founded in 1931, it was considered the most ambitious black newspaper effort in Tennessee. The connection with W.A. Scott's syndicate was part of the explanation, but the presence of a talented founding editor also contributed to such high expectations. The editor, Lewis Ossie Swingler, had recently graduated from the University of Nebraska-Lincoln and moved directly to Memphis to serve as the central figure to help commence the *Memphis World*. Swingler's move to Memphis was a return home of sorts, as he was born in nearby Crittenden, Arkansas, in 1906. He was raised primarily in Tulsa, Oklahoma, before earning his bachelor's degree in journalism and going to Memphis to work as editor of the *World*.[7]

From the first edition of the *World* on 28 June 1931 to its decline and eventual demise as a publication in 1973, the newspaper had to negotiate the complexities associated with advocating for racial pride and progress for blacks in Memphis, yet coexisting in a city that embraced traditional southern culture in which whites dominated the social, political, and economic landscape. Trying to balance such competing interests was not uncommon for the black press overall, particularly in major southern cities, but the large presence of African Americans in Memphis and the renowned public control exerted by Edward H. "Boss" Crump and others was particularly demanding for the *World*. Essentially, the *World* responded by sometimes challenging the black community to take head-on issues of racial disparity, and at other times wanting to be recognized as the voice of reason when there was increased potential for racial violence.

One example of the *World*'s aggressive stance occurred in 1948 with the issue of no presence of African American uniformed policemen in Memphis. As black leaders advocated for the city to break the color line in this profession, the newspaper consistently chronicled the push for the city administrators to address this societal inequity.[8] Interestingly, when the Memphis Police Department finally opened its entrance examination to African Americans, one of the original black officers hired was noted photographer and contributor to the *World* Ernest

Withers. Withers's pioneering presence as a policeman would be eventually surpassed by his unprecedented photography, some of which appeared over the years in editions of the *World*, capturing African American life and culture in the South. But only two years before supporting the desegregation of Memphis policemen, the *World* recommended its readership to "be constantly careful" so that "nothing" would happen "to cause an interracial clash" when four blacks were killed in a racial conflict that took place in Columbia, Tennessee.[9]

The *World* had enjoyed a twenty-year era as the premier black newspaper in Memphis when dramatic change occurred in 1951. In that year the *World* would face serious competition from the upstart *Tri-State Defender*, one of ten newspapers (including the *Chicago Defender*) controlled out of Chicago by the John Sengstacke family. The challenge from the *Tri-State Defender* was intensified by Lewis Swingler's ending his tenure as the *World*'s editor and assuming the role of editor-in-chief at the *World*'s new rival. Swingler's move to the *Defender* combined with Sengstacke support began a gradual decline in the *World*'s circulation and reputation as the leading black newspaper in the Memphis community.[10]

Alongside the *Defender*, the *World* maintained its commitment to racial pride and continued to monitor progress for African Americans locally and nationally. In particular, the *World* remained diligent in its coverage of national policy and local action related to civil rights as initiatives intensified during the 1950s and 1960s. But perhaps to its detriment, the *World* continued to reinforce its perspective of gradual yet sustained racial progress during an unsettling time when many African Americans in Memphis desired more assertive or confrontational stances on racial issues. For example, in the area of politics, the *World* never relinquished its public endorsement of the "party of Lincoln"—the Republican Party—despite blacks' locally and nationally increasingly looking to the Democrat Party for reform. This was most evident in the 1960 presidential election when the *World* endorsed Richard Nixon and the *Defender* endorsed John Kennedy.[11]

The *World* eventually ended publication in 1973. Although the newspaper was not sustainable beyond this point, it should not be dismissed as a failed attempt. Instead, the *Memphis World*

passed the torch to the next wave of the black press, which continues to have the important responsibility of offering alternative perspectives and support for the rich culture and contributions of African Americans.

Dr. Russell Wigginton
Vice President for College Relations
Rhodes College

[1] http://www.blackpressusa.com/history/gog_article.asp?newsid=2052.

[2] Roland E. Wolsley, *The Black Press, U.S.A.* (Ames: Iowa State University Press, 1971), 18.

[3] Samuel Shannon, "Tennessee," in *The Black Press in the South, 1865-1979*, ed. Henry Lewis Suggs (Westport, CT: Greenwood Press, 1983), 313.

[4] Ibid., p. 322.

[5] Ibid., p. 343.

[6] Alfreda Duster, ed., *Crusade for Justice: The Autobiography of Ida B. Wells* (Chicago: University of Chicago Press, 1970), 30-37.

[7] http://reportingcivilrights.loa.org/authors/bio.jsp?authorId=80.

[8] Ed Frank, "Memphis World," in *Tennessee Encyclopedia of History and Culture* (Nashville: Tennessee Historical Society, 1998), 616-617.

[9] Shannon, "Tennessee," 343.

[10] Ibid., 344.

[11] Frank, "Memphis World," 616-617.

EXPLANATION OF CAPTIONS

The photographs have been reproduced in their current condition with editor's marks, folds and tears, and, in some instances, staple holes. As noted in the introduction, the images were taken to document events in Memphis, and therefore were not conceived as precious, fine art objects. Once reproduced, they were deposited in files for future use or reference. Thus their appearance is the result of a long life, one begun in the newspaper business, subsequently housed in files, and now preserved in a museum collection.

Beside or underneath each photograph is the original caption published in the *Memphis World*. With few exceptions, these captions are reproduced exactly as they were printed, including misspellings, although some corrections were made for the convenience of the reader. Dates and page numbers serve to direct attention to the actual issues of the newspaper. When known, the photographer is identified. The accession numbers assigned by the Memphis Brooks Museum of Art are printed at the end of the caption. The complete cataloguing information for all of the photographs, which is not repeated throughout, is Memphis Brooks Museum of Art Purchase; funds provided by Sara and Kevin Adams, Deupree Family Foundation, Henry and Lynne Turley, Kaywin Feldman and Jim Lutz, and Marina Pacini and David McCarthy.

Accompanying the photographs are original entries written over the past year. Each is based on extensive research conducted in local libraries and archives, and on selected readings on the history and rhetoric of photography. These sources are listed in the acknowledgments and bibliography. Authors are identified by their initials.

To offer yet another perspective, one closer to that of the communities documented and celebrated in the *Memphis World*, an additional account is sometimes included with the entries. This appears as *Community Voices*. Whenever possible, the authors interviewed people who appear in the photographs or were familiar with the individuals and events recorded, or found materials in period publications that help to provide a fuller understanding of the imagery. These oral histories, newspaper accounts, and other materials further contextualize the photographs and serve as a reminder that meaning can easily change when one's focus is directed from the original place of publication, to historical research, and finally to the varied voices that continue to narrate Memphis's rich history. It is the authors' hope that the *Community Voices* section, though in many instances incomplete, will encourage continued engagement with the photographs.

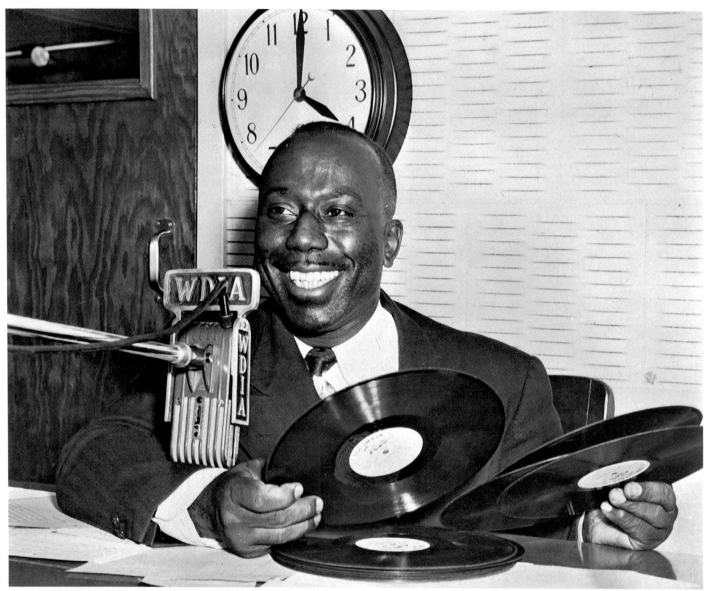

NAT D WILLIAMS nationally known journalist and disc jockey with WDIA radio station, served as Anniversary Editor for the writing of the "20 Years of News Highlights," appearing in today's paper.

Mr. Williams, teacher of social sciences at Booker T. Washington High School, was first invited to join the WORLD's staff as a columnist back in 1931. His column "Down On Beale," was an original feature of the Memphis WORLD, and helped to achieve for the writer recognition of national import.

Prof. Williams is married to the former Miss Lucile Butler. The couple are parents of two small daughters.

Memphis World, 3 July 1951, 8.
2006.31.99

Also published: *Memphis World*, 4 November 1949, 3; 21 November 1950, 2.

Nat D. Williams (1907-1983) is a legendary figure in Memphis history. Known to some as schoolteacher and to others as journalist for the *Memphis World*, Williams was best known for his role as the first African American disc jockey for WDIA.

In 1948, WDIA became the first station in the United States to cater to a black audience. Williams found the time to host three radio shows in addition to teaching. "Coffee Club" aired at 6:30 a.m. and "Tan Town Jamboree" aired at 4 p.m., both running Monday through Friday. "Brown America Speaks," a public forum, aired on Sunday afternoons. Although, when he began, WDIA's collections did not include any soul music, Williams soon found blues records to play, and increased airplay for local artists such as B.B. King, Rufus Thomas, and Elvis Presley.

Williams's charismatic and jovial personality radiates in this staged portrait, shot in the station's studios. Used for publicity purposes, the photograph draws attention to three focal points that are central to the picture's message. First, the records document Williams's renown for introducing soul music to the Memphis airwaves. Second, his face reveals his passion for his work in radio. His means of reaching the public, the microphone, ties his voice and the music together. Third, the clock positioned above his head reads exactly four o'clock, and likely serves as an advertisement for his show "Tan Town Jamboree."
AD

COMMUNITY VOICES

Interesting man, short in stature, but very powerful. . . . I graduated in '69, I took history from Nat D. Williams, my mother graduated I think in '38, she took history from Nat D. Williams. There were people who were just a part of the bricks over there at Booker T. Washington. That stability, that common, regular thing, people take for granted, but, you think about a people who are broken up as far as links to heritage and all those kind of things. It was very important, it was a very big thing for that school. Very prideful people at Booker T. Washington.

Joseph Nelson, interview with Marina Pacini, Memphis, TN, 18 April 2008.

State President Lover of Fine Dogs

Memphis World, 27 March 1951, 2.
RS2006.2.59

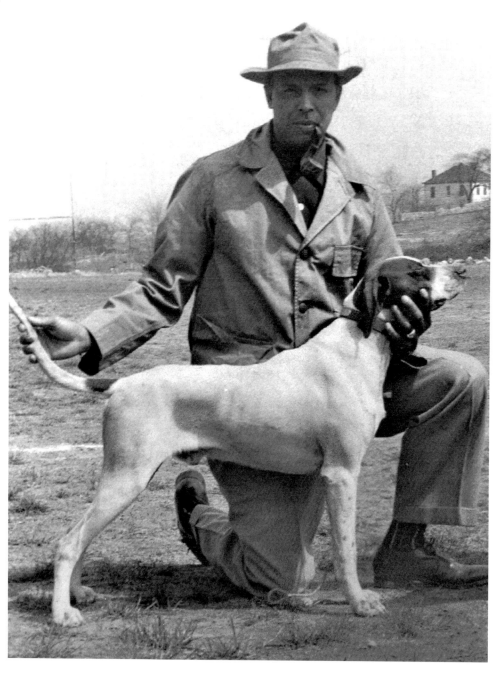

The National Championship for Bird Dog Field Trials has been held annually on the Ames Plantation, located just north of Grand Junction, Tennessee, about fifty miles east of Memphis, since 1915. In participating in the competition in 1951, Dr. Walter S. Davis hoped to continue his winning ways with his champion dog Vick's Airpilot Pat. The dog's stance reveals his award-winning physique, while Dr. Davis's pose is indicative of his skill as a dog trainer. Although dressed for leisure, the details of Davis's clothes suggest that the president of Tennessee State College has attired himself very intentionally for the day's event. His trousers retain a crisp pleat down the front and a clean cuff; he wears leather shoes and a pipe hangs casually from the corner of his mouth. Other details, such as the metallic nameplate on the dog's collar and the ring on Davis's left hand, are positioned carefully, denoting relational bonds. The trusting connection between dog and owner is formally confirmed by the lovely arc stretching from the dog's tail to its raised head, both ends of his body supported by the steady hands of a master sportsman.
AD & MP

COMMUNITY VOICES

Dr. W.S. Davis, president, Tennessee State College, displays one of his bird dogs.

The dog, named "Vick's Airpilot Pat" is being groomed for the coming Spring Bird Dog Field Trials. Last Spring "Pat" won the title "Champion Two-Year-Old Bird Dog." This Spring, Dr. Davis hopes that "Pat" will successfully defend the title "Grand Champion for All Ages," which was won last year by "Tennessee's Miss Joy," also owned by Dr. Davis.

These dogs were trained by Rev. James Moore of Memphis and were shown by H.C. Hardy and Eddie Williams of Nashville.

Dr. Davis, Dr. C.A. Treherne and Dr. H.H. Walker, all members of the Nashville Sportman's Club, jointly own and operate an outstanding Bird Dog Kennel. In this Kennel are found Pointer and English bird dogs with the best blood lines known in this country. Both "Tennessee's Miss Joy," and "Vick's Airpilot Pat" are descendents of "Air Pilot Sam," twice world champion.

Dr. Davis, recently chosen as a member of the Chicago Defender's Honor Roll" as an outstanding land grant college president, is also known to be an outdoor sportsman. Killing the bag limit of quail and catching the day's limit of game fish are habits with him. He has won many Trap Shooting contests.

Dr. Davis was three-letter-man while in college and formerly served four years as head football coach at Tennessee State.

"State President Lover of Fine Dogs," Memphis World, 27 March 1951, 2.

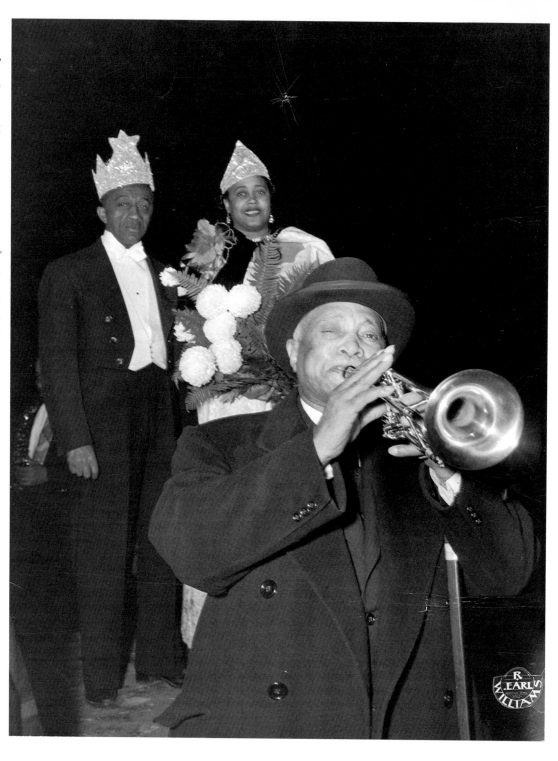

THE "KING" AND, "QUEEN" LISTEN TO THE "MASTER"—Blind and aged, but still able to hold multitudes spell-bound with the golden notes of his golden trumpet, W.C. Handy, the "Daddy of the Blues," blows once again in Memphis. He played the songs that made him famous before six thousand fans at the 14th annual Blues Bowl Game Tuesday night at Melrose Stadium. Behind him are, left: Maurice Hulbert, who was crowned "King of the Blues." He escorts Mrs. Jana Cox, "The Queen of the Blues," who made a record in ticket sales.

Memphis World,
7 December 1951, 1.
Photograph by R. Earl Williams.
RS2006.2.70

The Blues Bowl was established in December 1939 by Lt. George W. Lee and the Beale Street Elks Club as a "display of allegiance" to Edward Hull Crump's political machine. In 1939, Beale Street business owners and black Republicans J.B. Martin and Elmer Atkison denounced Crump, who responded by raiding their Beale Street businesses. Memphis police harassed patrons and arrested "undesirables." In this heated political environment, Lee established the Blues Bowl to unite the African American businesses of Beale Street with the white political establishment on Main Street. He assembled an interracial committee to plan and host the annual football game, an event the *Commercial Appeal* claimed benefited Memphis's "most destitute Negroes."

In this photograph, William Christopher Handy stands in front of the king and queen, affirming that he was the main attraction of the evening. A dramatic diagonal begins with the sheen on his horn and ends with Mrs. Cox's smile. Beside her, the king stands casually with relaxed shoulders and a dry expression. At halftime, Handy enchanted the 6,000 people gathered in the stands with his signature number, "The Memphis Blues." Fifteen hundred whites had gathered in the segregated stands, but black and white listened as one when Handy played, leaving only blue notes drifting from the bell of his golden horn.
AS

COMMUNITY VOICES

"If (my) old horn is ever recovered by the police, I want to give it to the City of Memphis so that it may be enshrined in a glass case in Handy Park as a sort of monument to 'The Memphis Blues,' which I played upon it many thousands of times," Prof. Handy said.

"Overton Accepts Invitation to Head Committee for Handy," *The Commercial Appeal*, 27 November 1951, 17.

At Melrose stadium at 8 tonight, Prof. Handy again will play a refrain from Memphis Blues on his new trumpet, which replaces one stolen from his car. It was flown from C.G. Conn Co., Elkhart, Ind., for Handy to use at the 13th annual Blues Bowl game tonight, sponsored by the Beale Street Elks for the needy at Christmas.

"Out on that Rain Floats Famous Memphis Blues," *Memphis Press-Scimitar*, 3 December 1951, 31.

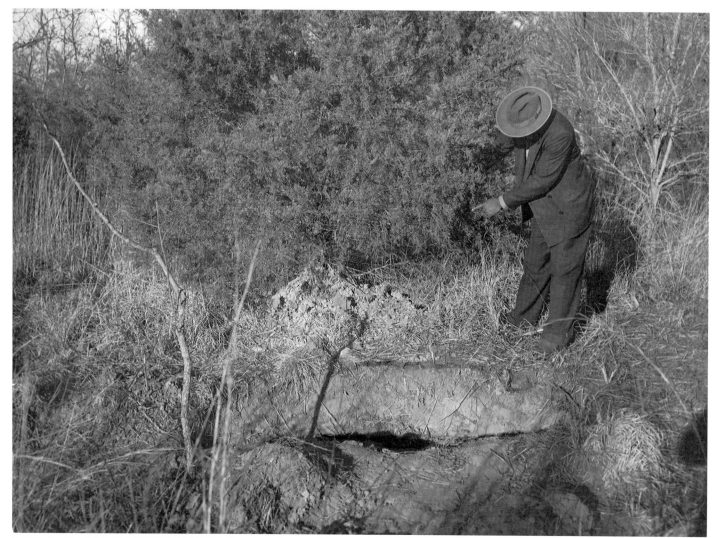

WHERE MR. HULON'S BODY WAS FOUND—Jesse Esters of the Qualls Funeral Home points to the shallow grave where the body of Walter Hulon was found last Friday. Two hunters – one white and one Negro – discovered Mr. Hulon's clothes and informed the Shelby County Sheriff's Office. Upon investigation, deputies found the body in the hole. An evergreen tree in the background had been dug up from the spot and re-planted. Elaborate attempts were made to conceal the grave.

Memphis World, 22 January 1952, 1.
Photograph by Qualls.
2006.31.9

"Aged Couple's Murder Shocks Shelby County" was the headline for this photograph's gripping story. On 12 January 1952, Grover Richardson and Willie Leroy Becton, both in their twenties, approached the Oak Grove home of Walter and Savannah Hulon demanding $1,800 the couple had received from a recent property sale. When Mr. Hulon was unable to provide the sum, the men shot him and then buried him in a shallow grave. Mrs. Hulon's body was found in the couple's home. Ten days later, the Tennessee Bureau of Investigation arrested Richardson and Becton. Each man confessed his part in the murders, with Richardson going on to confess his role in the 7 January murder of Fayette County farmer Irwin Bailey Morrison.

Murders were covered extensively by the *Memphis World*, and this particular case landed on the front page of the *Commercial Appeal*. Memphians gained access to the crime scene via the photograph taken by an employee of the Qualls Funeral Home. Jesse Esters provides a focal point and establishes scale in an otherwise overgrown, unkempt area of brush. His solitary placement mirrors the isolation of the makeshift grave before him, the pointing finger of his outstretched arm directing attention to Mr. Hulon's final resting place.
RT

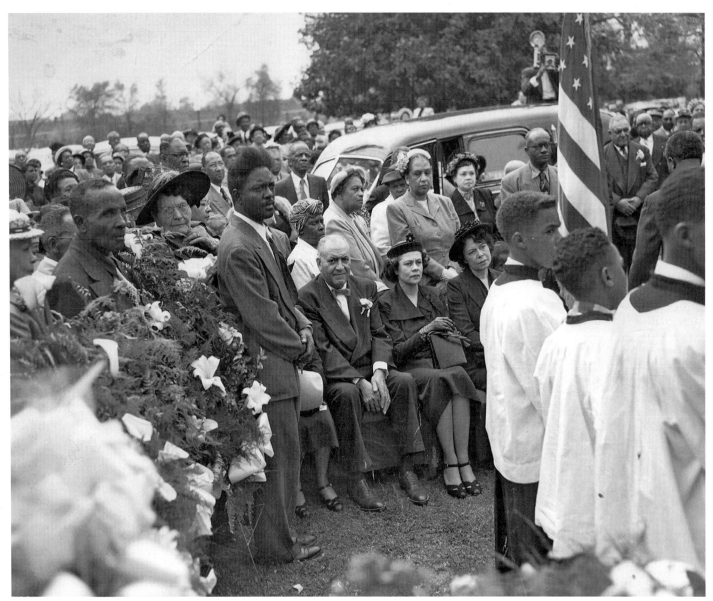

"THE GOOD IS OFT INTERRED WITH THEIR BONES . . ." This assemblage of people witnessed the interment Sunday of R.R. (Bob) Church, Jr., who was laid to rest in the Church family mausoleum at Elmwood Cemetery. The funeral chapel, the building and the whole area surrounding the T. H. Hayes and Sons Funeral Home were jammed with the 600-odd whites and Negroes who came to pay their last respects to the most colorful political figure the Negro race has ever produced. Seated in the center fore-ground are Dr. J.B. Martin, Miss R. Savannah Church and Mrs. Marie Wright Smith (a cousin) of Chicago and Washington.

Memphis World, 25 April 1952, 1.
Photograph by Hooks Brothers Photography.
RS2006.2.30

The son of the first African American millionaire in the United States, Robert "Bob" Church Jr. always considered Memphis his home. He was influential in the political life of the Memphis Republican Party; it was said that one could not get a Republican appointment without going through Bob Church. He remained intimately connected to the city until 1940, when political boss E.H. Crump launched his reign of terror. The systemized attack on black Memphis culminated in the destruction of Church's childhood home after he had moved to Chicago. He died of a heart attack in a Memphis hotel, having returned home in an attempt to reestablish his local political position.

Church's distinction and importance are underlined by the presence of the press at an event usually reserved for close friends and family. The photographer focused on the crowd in attendance rather than on the ceremony, calling to mind the saying that the funeral is not for the dead, but for the living. The sea of faces stares toward the casket, where a local hero is retired to his family mausoleum.
EW

COMMUNITY VOICES

White people knew him and his family as a contradiction to the backward pictures of the Negro they had been conditioned to accept. The Church family could rank with the best any group could offer in America. They were ambitious, energetic, aggressive, and successful. They combined all the ingredients which Americans regard as great in folks.

Among Negroes the Church family stood as a symbol of inspiration and achievement. Many Memphians basked in the sunshine of the Church name. Even though they had never met him, they could speak with pride about the sayings and doings of "Bob Church."

Editorial, *Tri-State Defender*, 26 April 1952, 4.

Robert R. Church and Memphis were synonymous.

This courtly Southern Gentleman and astute politician represented Memphis at its best, and when he died a great void was left.

Born to wealth and acquiring more by astute management, Bob Church could have divorced himself from the problems of his people and retired to some pleasant strand far from the worries and tribulations of Aframerica.

Instead, he unselfishly threw himself into the Negro's struggle and used his money, time and influence to further the interests of his people in their struggle for full citizenship in our Republic.

"The Gentleman from Memphis has Gone," *The Pittsburgh Courier*, 3 May, 1952, 6.

ATTORNEY H.T. LOCKARD AND "STAR" MCKINNEY CROWNED KING AND QUEEN OF 1952 "COTTON MAKERS' JUBILEE"—It was in the club rooms of the Lumpkin Hotel that the 1952 Royalty (who will reign over the "Cotton Makers' Jubilee") were crowned Monday night—They are Attorney H.T. Lockard, promising young lawyer who is associated with Attorney A.A. Latting, who will rule as King, and Mrs. Versi "Star" McKinney, Radio Station WDIA's Tan-Town Society Reporter is the 1952 Queen. At the right is Ms. Ann Cousins, princess to the Queen.

Memphis World, 25 April 1952, 1. Photograph by R. Earl Williams. 2006.31.108

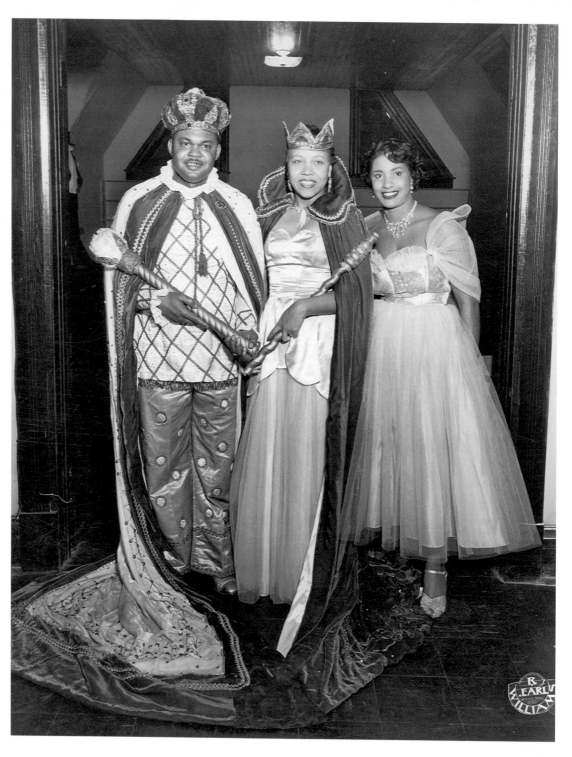

H.T. Lockard and Versi "Star" McKinney ruled over the 1952 Memphis Cotton Makers' Jubilee. The king and queen were often socially prominent Memphians, and their reign was covered extensively in the society pages of the local papers. Lockard's fame was tied to his legal practice, which included significant civil rights activism. In January 1955 he became president of the local chapter of the NAACP. McKinney was a popular society reporter and later cohost of the music program "Boy Meets Girl" at WDIA, the radio station noted for its programming by and for African Americans. The framing of the composition is tightly focused on the royal couple and their attendant, photographed in the lobby of the Lumpkin Hotel.

The Jubilee, first staged in 1936, existed as a parallel event to the segregated Memphis Cotton Carnival, which originated in 1931. Both carnivals endeavored to create a romanticized identity, one that had little grounding in fact, however, and instead reverted to generalized interpretations of antebellum history. Reflective of this sensibility is the clothing worn by the royal couple in this photograph. Their crowns and scepters are decorated with faux jewelry, while their costumes are equally staged. Although the royal couples in both carnivals appeared in clothing representing monarchal power, the separation dividing the two events echoed the lack of full equality between Memphians.

BJ & MP

COMMUNITY VOICES

I feel compelled to tell you what a profound bigot our local district judge was. He was such a notorious bigot that he wouldn't even look at me when I went in the courtroom. Marion S. Boyd, he was so disrespectful. The defense never came into court on their own asking for anything. They were always there responding to what I was asking for. He had the audacity to address the defense lawyers as to why they were there. He did not even show me the respect of being a lawyer in the courtroom on a case. . . .

I got so frustrated at one of Thurgood's meetings. . . . I have to say a word about Thurgood Marshall, he was a very gruff person but a very warm person. . . . He referred to all the fellows in the circle as boys, boy this, boy that. I . . . think we were in Houston at a legal seminar. I was in my middle 30s, and I was describing this conduct of Judge Boyd. I wanted to file an action against a federal judge. "Boy, you can't do that, you never will win a case before a judge like that." I said, "I don't practice in federal court." [B]ut I got encouragement from one of Thurgood's buddies, a very brilliant man, . . . James Nabrit, former president of Howard University, former dean of the law school, a very capable man. He said, "Lockard, go ahead and file it. Sometimes you get attention from judges when you file something crazy. He cited an incident where he was arguing a case before the U.S. Supreme Court. . . . His argument was that appealing the separation in the civil rights cases was tantamount to a Bill of Attainder. He said, [it was] the first time that Justice Frankfurter even looked up—he sprung up in his seat—he was so surprised to hear the argument. And I liked that.

And I filed it. . . . Without enumerating because I don't remember all the things I said about Judge Boyd—but to say the least, all of the allegations about his ignoring the rules of evidence and so forth—the opinion came down, we do not find Judge Marion S. Boyd guilty of the allegations as the plaintiff has alleged but we do feel within the not-too-distant future he will set these cases for hearing. And he did just that. We could not appeal because we didn't have a ruling to appeal from. It was just a matter of putting off [the cases].

H.T. Lockard, interview with Marina Pacini, Memphis, TN, 25 April 2008.

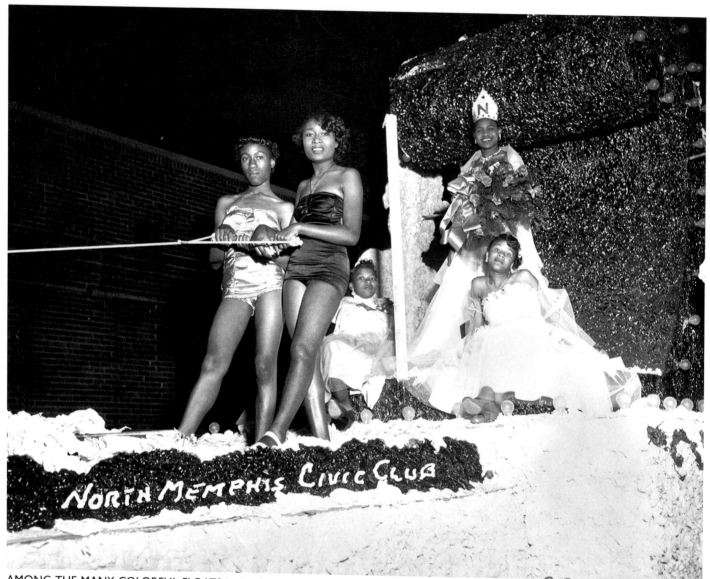

AMONG THE MANY COLORFUL FLOATS in the Cotton Makers' Jubilee Parade Friday night was the one above entered by the North Memphis Civic Club. Queen Jean Harper is shown behind the two surfboard riding lassies.

Memphis World, 20 May 1952, 3.
Photograph by Hooks Brothers Photography.
2006.31.110

This image of the queen of the North Memphis Civic Club combines the symbolism of royalty with that of a liberated perspective of beauty. Every year the Memphis Cotton Carnival on Main Street functioned as a showcase for the most fashionable and beautiful girls of Memphis society. The same was true on Beale Street with the Memphis Cotton Makers' Jubilee, where young women from African American society were paraded forth, literally.

Positioned on the back of the float, Jean Harper is placed higher than all of the other passengers. This point is emphasized by the fact that the photograph is shot from below the float. Two attendants dressed in white ride to either side of her, while two women in bathing suits stand at the front edge of the float holding a rope that suggests they are waterskiing. Publication of such images in the *Memphis World* countered the stereotypes often presented within the dominant culture, and thereby supported black women's emancipation from racist representation.

BJ

COMMUNITY VOICES

The things that Daddy [Manassas art instructor Walter P. Guy] decorated were always "off-the-chain," as the kids say now. . . . His decorating was always thematic. . . . The theme here was a surfboard ride, which is totally out of our culture. He would come up with things that people had never seen or experienced to expose us to more stuff.

Francine Guy, interview with Marina Pacini, Memphis, TN, 3 July 2008.

GREAT LEADERS—In the picture three great leaders look to the future and plan for Equality for all People, they are standing left to right: Hollis Price, President of LeMoyne College, Memphis; Walter White, Executive Secretary of the NAACP of New York City, and Mr. Utillus Phillips, President for 12 years of the Memphis Branch of the NAACP. Mr. Phillips presided over the Mass Meeting held at the Metropolitan Baptist church, McDowell at Walker Sts., Sunday evening, 3:30 p.m. Sunday, June 22nd.

Guest speaker for this mammoth occasion was Attorney Harold Flowers of Pine Bluff, Ark., who is currently leading the fight for integrated schools in the State of Arkansas.

Memphis World, 24 June 1952, 5. Photograph by Hooks Brothers Photography. RS2006.2.22

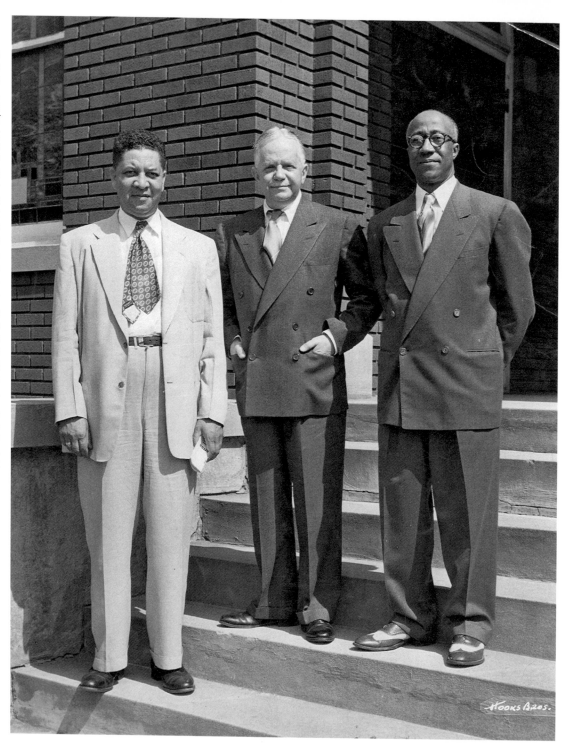

Three powerful male figures within the civil rights movement stand arm to arm as they gather to decide how to guide the local branch of the NAACP toward its goal of a balanced community. Although the three physically stood together in unity for the photograph, they were not united in their plans for Memphis. The national goals of the organization regarding segregation interfered with the goals of the local branch.

Memphis leaders, working in politics, education, and religion, had been struggling for years to have a Negro hospital built to address the needs of the city. As was the case nationally, there was a lack of institutions providing health care for African Americans, as well as places where black medical professionals could be employed. The national officers of the NAACP opposed the construction of any new segregated hospitals. Local black leaders, however, felt that there was a dire need for a facility, whether integrated or not, and that the segregated plan would in effect lead to future integration. The opinions of the opposing leaders, no doubt, were as strong as their firm stances—fully frontal with intent gazes.
CW

COMMUNITY VOICES

I hope we can get all those interested in helping Memphis to have a real, fully accredited hospital, which Negro doctors and nurses can use.

"Get $508,615 for 125-Bed Medical Center," *Tri-State Defender*, 31 May 1952, 3.

The great need for more Negroes in the medical profession is known and felt throughout the country.

"Meharry Moves Ahead," *Tri-State Defender*, 21 June 1952, 4.

RESUMES LAW PRACTICE, Attorney J.F. Estes, having completed a two year Military Tour of Korea has re-opened his law office at 145 Beale, Avenue.

Memphis World,
16 September 1952, 1.
2006.31.61

Also published:
Memphis World,
27 May 1952, 3;
Memphis World,
25 December 1952, 1;
Memphis World,
27 February 1953, 1;
Memphis World,
15 June 1954, 10;
Memphis World,
20 October 1956, 8;
Memphis World,
22 October 1960, 1;
Memphis World,
12 August 1967, 1.

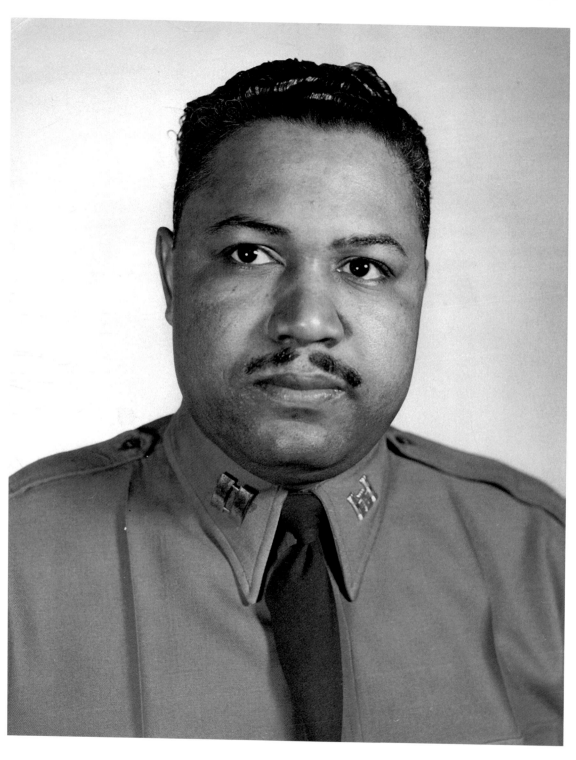

An unassuming photograph of a captain in the U. S. Army Corps of Engineers finds him staring beyond the lens of the camera, as if anticipating his next assignment, or at the very least, thinking about the work to which he needed to return. Both the uniform and the gaze mark James F. Estes as a figure of service, action, and accomplishment.

Born in Jackson, Tennessee, in 1919, he graduated from Lane College (Jackson, TN) in 1942 with a B.A. in sociology. Shortly thereafter he joined the U. S. Army, rising to the rank of lieutenant during World War II, serving again during the Korean War, and subsequently attaining the rank of major in the reserves. In 1948 he completed his legal degree at the Marquette University School of Law. That same year he set up practice in Memphis with an office on Vance.

Over the next two decades he played a pivotal role in Memphis, challenging segregation at Memphis State University (1955), establishing the Veterans Benefit Association (1956), and defending Rev. Burton Dodson in the murder case (1959) that led to voter registration and Tent City in Fayette County, Tennessee. He was among a distinguished group of lawyers—including Benjamin Hooks, H.T. Lockard, Ben F. Jones, Russell Sugarmon, and A.W. Willis—who joined the local branch of the NAACP in the postwar years and led the legal campaign against Jim Crow. From 1961 to 1967 Estes served as pastor for the Vance Avenue Baptist Church. When he died in 1967, he had just begun his pastorate of the First Baptist Church in Glen Cove, New York.
DMcC

COMMUNITY VOICES

Estes did some defense work, he did a lot of criminal law. There wasn't a broad reach you could make a living on as a lawyer, there were divorces and estates. With us, because we were identified as the NAACP, if anyone had a big accident, they didn't go to us because if it went to a white jury, they figured we'd be handcuffed. So we had a hard time getting the good cases. Ours was a labor of love, up to a point.

Russell Sugarmon, interview with Marina Pacini, Memphis, TN, 14 March 2008.

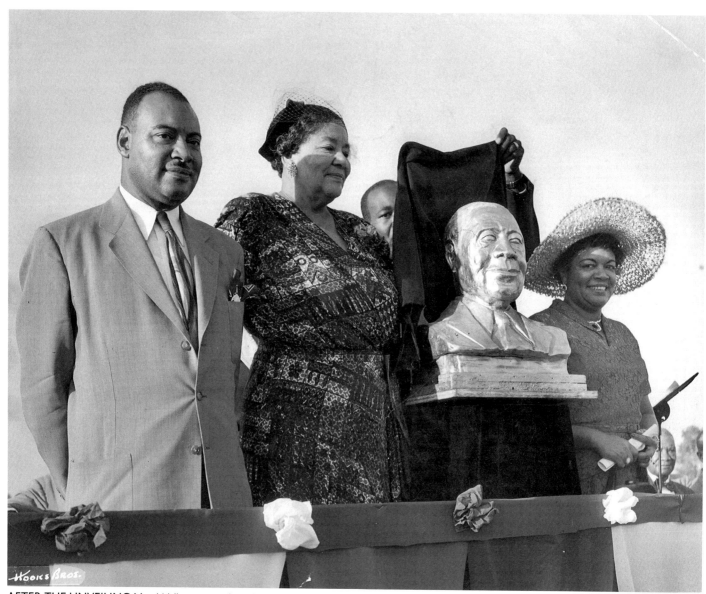

AFTER THE UNVEILING Mrs. Walker poses alongside of bronze statue with her son A. Maceo Walker and her daughter Johnetta Kelso.

Memphis World, 3 October 1952, 6.
Photograph by Hooks Brothers Photography.
RS2006.2.45

Dr. Blair T. Hunt unveils a bust of Dr. Joseph Edison Walker at the opening of Walker Homes, which according to the developers was the nation's largest black subdivision in 1952. Housing conditions for many African Americans in Memphis were deplorable. Typhoid fever and tuberculosis were epidemic. The development of three public housing projects—Dixie Homes, William H. Foote Homes, and LeMoyne Gardens—alleviated these public health problems. Increased home ownership also helped to erode urban poverty. Rows of slums and shacks were replaced with well-constructed houses. Dr. Walker knew that a black subdivision designed for 1,500 families was a sound social and financial investment in his community.

The central figure in this photograph is Mrs. Lelia Walker, who, with her children, proudly stands next to her husband's bust. The rolled up paper in Johnetta's hand is likely the program for the groundbreaking ceremony, which nearly 6,000 gathered to witness. Dr. Walker is confined to the corner of the photograph, obscured by a music stand. In contrast, A. Maceo is pictured prominently. He took over his father's position as president of Universal Life Insurance Company the year this photograph was taken. The Walker family joins Memphis in honoring Dr. Walker's legacy, a man preserved in this bust and the homes constructed in his name.
AS

COMMUNITY VOICES

"A home owner is a more substantial citizen because he feels a sense of belonging. The Continental Land Company has done much to eliminate slums and raise the economic standard of the colored people by giving them a better home in which to live and rear children. As a sponsor of these projects, we are proud of the part we played."

J.E. Walker quoted in "Largest Subdivision of Kind In Country," *Commercial Appeal*, 28 September 1952, Section III, 10.

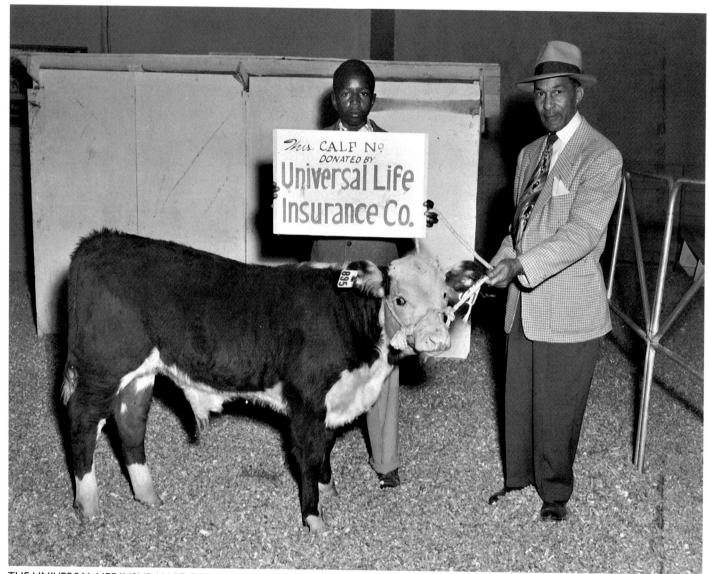

THE UNIVERSAL LIFE INSURANCE COMPANY OF MEMPHIS, bought the above calf weighing more than 350 pounds. The calf was won by Joe L. Wilson, 15, son of Mr. and Mrs. Joe Wilson of Sardis, Mississippi at the recent Tri-State Fair.

Memphis World, 21 October 1952, 1.
Photograph by R. Earl Williams.
2006.31.125

This photograph serves as an explicit endorsement of future "new Negroes," an early-20th-century concept describing black individuals who advance into successful business enterprises, and simultaneously advertises the Universal Life Insurance Company (ULIC) as a powerful local business serving fellow blacks. On the company's behalf, Lucky C. Sharpe, special ordinary representative, presents Joe Wilson with a calf due to the young man's interest in farming as a career. Through its charitable giving, ULIC advocated self-help and black capitalist efforts, while advancing its own entrepreneurial goals. These activities sent a message of encouragement and motivation to the African American community.

Attention is immediately drawn to the sign that establishes the company's presence and influence. The rectangular backdrop behind Wilson repeats the shape of the sign and frames the interaction staged in the foreground. Sharpe's attire, including a tailored houndstooth jacket, cuffed and crisply ironed slacks, and a fedora, are juxtaposed with the farm atmosphere. His slight smile contrasts with Wilson's straightforward stare. The rope serves as the unifying element, arranged appropriately in a triangular shape linking the three principal subjects.

AJ

OFF TO W. C. HANDY'S BANQUET

left to right: Mrs. Matthew Thornton, Jr., Matthew Thornton, Jr., U.S. Postman and Matthew Thornton, Sr., Mayor of Beale Street and retired Special Deliveryman of the U.S. Post Office Department of Memphis, Tenn., left Tuesday night for New York City to attend a testimonial banquet at the Waldorf Astoria hotel in honor of W.C. Handy, former Memphian and famed "Father of the Blues."

Ed Sullivan, the New York columnist who is seen on TV each Sunday night in "Toast of the Town" and Noble Sissle, the orchestra leader, are the co-chairmen of the committee arranging the dinner.

The dinner honoring the maestro on his 79th birthday was held at the Waldorf Thursday, November 13th. Other Memphians invited to attend the dinner but were unable to attend because of pressing business were Lt. George W. Lee, Insurance executive and James H. Purdy Jr., Editor of the Memphis World.

Memphis World, 14 November 1952, 1. Photograph by Hooks Brothers Photography. 2006.31.67

Matthew Thornton Sr. is accompanied by his son and daughter-in-law as he departs Memphis to celebrate W.C. Handy's 79th birthday. They are fashionably dressed for the occasion with the men in suits, ties, and hats; Mrs. Thornton Jr. wears a coat and mink stole, while carrying a hatbox from Lowenstein & Bros. and an alligator purse. Arranged in a pyramid and framed by the railing, they present a tight-knit group as they embark for the special occasion.

In 1938 Matthew Thornton was elected the unofficial Mayor of Beale Street in a contest organized and run by the *Memphis World*. Of the twelve candidates on the ballot, Thornton received 12,000 of the approximately 33,000 votes cast. The contest was followed nationally and was reported in the *New York Times*. As there was never another election for the Mayor of Beale Street, Thornton Sr. retained the title throughout his life. The position made him an unofficial spokesperson for various events and also transformed him into a local celebrity.

LW

COMMUNITY VOICES

Thornton began his career in Memphis by organizing the first recognized negro brass band more than 40 years ago. It was through the influence of Thornton that William C. Handy, "Daddy of the Blues," moved to Memphis from Clarksdale, Miss., and Prof. George W. Henderson, founder-president of Henderson Business College, moved to Memphis from Nashville. Prof. Henderson will pay tribute to Thornton as a citizen Sunday.

Thornton's contributions to Memphis include establishment of safety councils in negro schools, organization of the Harmony Club for higher type recreation among his people, getting the city to employ two full-time negro sanitary officers, getting Kroger to use negroes as clerks, butchers and store managers in neighborhoods predominantly negro.

"Both Races Will Honor 'Mayor of Beale Street,'" Memphis Press-Scimitar, 11 May 1943, 11.

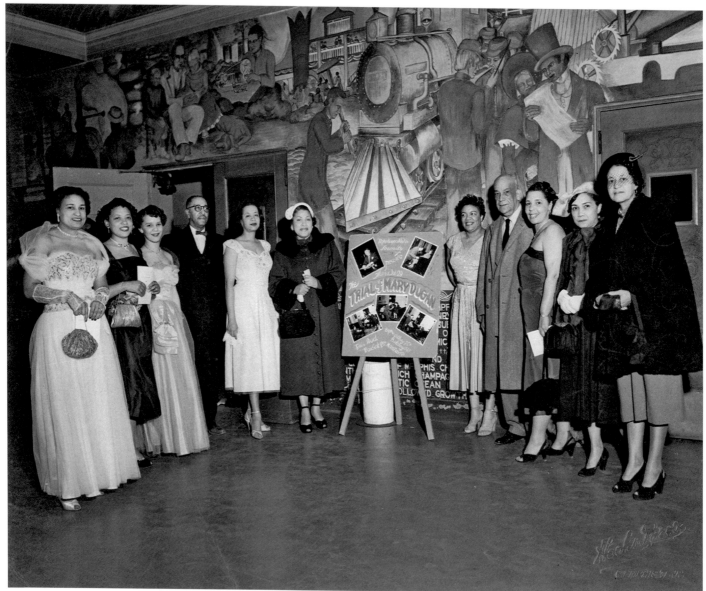

CURTAIN TIME FOR "THE TRIAL OF MARY DUGAN," play given Thursday night by members of the Alpha Kappa Alpha Sorority at Ellis Auditorium. A group of A.K.A. members pose in the lobby just before curtain time with a few guests. Reading left to right are Mrs. T.M.R. (Helen) Howard, member from Mound Bayou, Miss., Miss Katheryn Perry, Chairman of the play; Miss Helen Ann Hayes, made at Fisk University last year; Dr. A.B. Carter, Mrs. Oscar Speight, Jr., also an Alpha Kappa Alpha woman; Mrs. Alex Dumas, Mrs. Julian Kelso, A.K.A.; The Reverend Mr. Blair T. Hunt who gave the verdict of the trial from the audience; Mrs. Harold (Marion) Johns, basileus of the local graduate chapter that gave the play; Mrs. Russell Sugarmon, and Mrs. Utillus Phillips.

Memphis World, 3 February 1953, 8.
Photograph by Hooks Brothers Photography.
RS2006.2.18

In glamorous evening wear, members of the local graduate chapter of the Alpha Kappa Alpha Sorority, Inc. (AKA) and their guests welcome the audience to their sixth annual play, *The Trial of Mary Dugan*. In the courtroom drama written by Bayard Veiller and presented on Broadway in 1927, Mary Dugan is on trial for the scandalous murder of her latest lover. The production was directed by Mrs. Ann Reba Twigg as a fund-raiser for local projects and took place in Ellis Auditorium. Residents from the community also participated in these performances. Local leader Rev. Blair T. Hunt is the only person pictured who actually took part in the play.

Founded at Howard University in 1908, the AKA sorority provided African American women with a social network on campus and nationwide. In this photograph the fashionably dressed men and women stand in a semicircle. In contrast with the mural behind them depicting stereotypical 19th-century imagery of blacks as slaves and workers, these AKA members and their guests clearly represent the upper class of black Memphis.
LC

COMMUNITY VOICES

During the time I was president we engaged in a health program, . . . we gave scholarships . . . and we accomplished many things in the way of helping people. . . . I loved the sorority. It stood for womanhood, scholastic aptitude, and scholastic experiences. At that time . . . it was really hard to get in, you had to have good scores, a good reputation. . . . The graduate chapter was women who had been made in other schools—Fisk, Howard, and other universities—and were living in Memphis. When they got enough women together they formed a chapter, Beta Epsilon Omega, that's the oldest chapter here. . . . It was a wonderful chapter, we did a lot of good work. And the plays were excellent. We used a lot of local people, some sorority folks, and some not sorority. . . . With The Trial of Mary Dugan, I took a group and went to the courthouse and asked the judge if we could use one of his chairs [laughs]. And he said yes. . . . Ask anybody, I wasn't afraid of nothing, I just asked. And I think he came to the play. It was packed. We had a play every year for eight years, everybody looked forward to going to it. It was the big night out. . . . That was the last play we had. . . . I chose The Trial of Mary Dugan because of the suspense it had. The audience was quiet to the last minute listening to it.

Katheryn Perry Thomas, interview with Laura Cross, Memphis, TN, 28 November 2007.

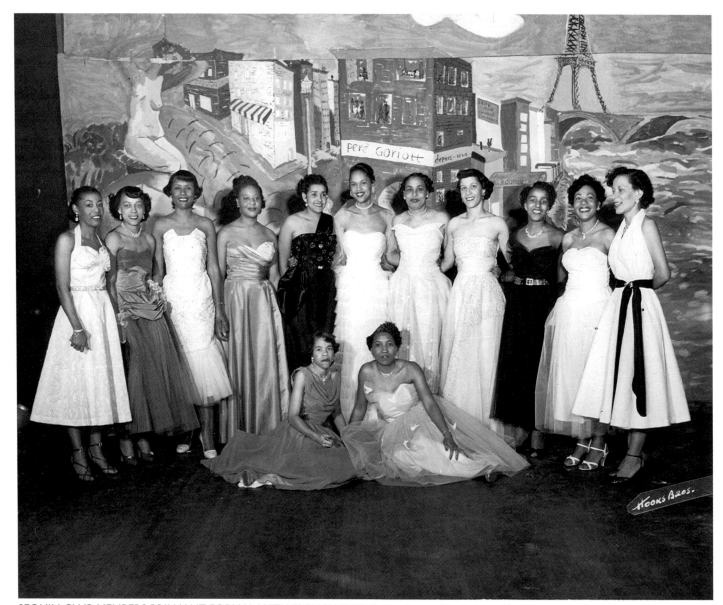

SEQUIN CLUB MEMBERS BRILLIANT FORMAL WITH FRENCH THEME: Members of the fashionable show are reading left to right (front row) Mrs. Mildred Williams and Miss Mary Cotton. Back Row: Miss Juanita Brewster, Mrs. Alice Oates Sandridge, Miss Ruby Harris, Miss Alice Gilchrist, Mrs. Helen Prater, Mrs. Beverly Ford, Miss Almazine Davis, Miss Margaret Bush, Mrs. Matilda Freeman, Mrs. Katherine Thornton Simmons, and Mrs. Ruth Holmes, president of the club. Several of the members do not appear in the picture.

Memphis World, 17 April 1953, 3.
Photograph by Hooks Brothers Photography.
2006.31.53

The Sequin Bridge Club, a group that gathered on Saturday evenings, put on their April in Gay Paree formal in 1953. Social clubs typically held such events every two or three years. In the photograph, each of the women wears an elegant dress complemented by an updo or curled hair, jewelry, and high heels. Their sparkling smiles reflect the glamour of their club, the formality of the event, and the Parisian culture they sought to re-create thematically.

The women pose in front of a backdrop connoting bohemian culture and depicting landmarks such as the Eiffel Tower and the Pont Neuf, the famous bridge spanning the River Seine. The painter labeled the large building in the center in reference to Honoré de Balzac's 1835 novel *Le Père Goriot,* the story of a bright young law student determined to succeed in Paris. According to an article in the 17 April *Tri-State Defender*, the scene depicted Pigalle, the Parisian street where American soldiers spent their free time. During World War II, African American soldiers on leave found that they were able to do many things in Europe that were prohibited in the Jim Crow South, including dancing in integrated nightclubs.
MM

COMMUNITY VOICES

Al Jackson and his famous orchestra wore black berets. There were even French pictures and scenes giving one the real feeling of being in Paris. When Sequin Club members gave one of the most brilliant dances ever last Friday night. The Hippodrome has never looked prettier and the seating arrangement was most unusual and clever with an opening that went completely to the back of the ballroom and showed off a Paris street scene in Paris. The Sequins presented a floor show during intermission. In Paris there is graceful living and romance all around.

"Sequins Bridge Club's Brilliant Formal Features 'An Evening in Paris,'" *Memphis World*, 17 April 1953, 3.

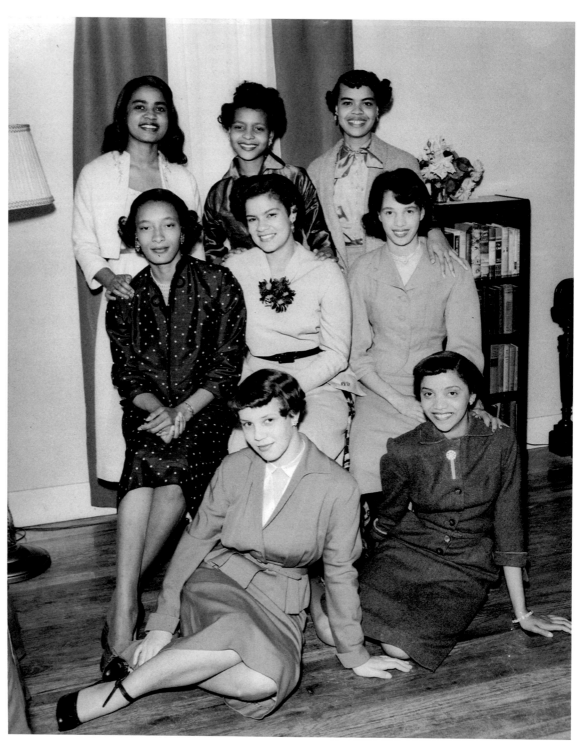

YOUNG SET ORGANIZE J-U-G-S SOCIAL CLUB—
Reading left to right are (front row): Miss Helen Ann Hayes, and Miss Irma Laws. Second row: Miss Velma Lois Jones, Mrs. Martha Jean Steinberg and Miss Marie Bradford. Back row: Miss Sarah McKinney, Mrs. Josephine Bridges and Mrs. Florence Grinner Marsh.

Memphis World, 24 April 1953, 3. Photograph by Ernest C. Withers. 2006.31.16

Founded in 1953, JUGS was created by teachers Josephine Bridges and Sarah Chandler after they noticed that children in Memphis City Schools did not have adequate food and books. Initially, the group's name was an acronym for Just Us Girls. The young women used social events as a forum for service activities. The bookshelf and lamp in the background of the photograph reveal that a number of gatherings took place in members' homes because segregation limited African Americans' use of appropriate facilities.

As the organization developed, JUGS changed the meaning of their acronym to Justice, Unity, Generosity, and Service to reflect better their service-oriented purpose. They also expanded beyond Memphis, forming branches in Washington, D.C., Miami, and even Nassau, Bahamas. During the 1950s and 1960s, these young ladies broke ground by stepping beyond the gender norms of the era. With their commitment to service, they contributed to the civil rights movement. They supported African American politicians and even held events in facilities and public hotels such as the Hippodrome and the Peabody. Furthermore, JUGS made these occasions the highlight of the social scene—these elegant socialites made charity fashionable.
CW

COMMUNITY VOICES

I founded it along with my friend Sarah Chandler. We were both teaching school and noticed that the kids were behind. We wanted to help them. Primary focus has always been the children. The women were typically teachers, and all had finished college. We weren't wealthy women and couldn't just ask our husbands for money. JUGS had to work. We wanted to be more than just a party group. The JUGS used parties, charity balls, etc. as fund-raisers. During these events, people came from Memphis and other cities and donated. The funds were always used towards the community, particularly children.

JUGS had young girls whom they worked with, the Living Ads. They were high school seniors who had to be recommended by their teachers and guidance counselors. The JUGS mentored these young ones. Young girls couldn't wait to be Living Ads and represent their schools. It was the only real opportunity that black girls had to be shown in a social setting. As the JUGS began to do more in the community, they wanted to drop the "Girls" part particularly. They helped people running for office like Otis Higgs and A.W. Willis, who ran for mayor, and they had a lifetime membership with the NAACP.

Josephine Bridges, interview with Crystal Windless, Memphis, TN, 6 October 2007.

QUESTION: POLICE ORDER STATES THAT ONLY COUPLES MAY VISIT NIGHT CLUBS OR DANCE HALLS. WILL THIS STOP YOU FROM VISITING THESE PLACES OF ENTERTAINMENT?

WHERE: Along Beale Street

George Johnson, 1327 South Main. Salesman: "Yes it will stop me from going out lots, because I don't want to be in a couple every time I go out." "I like to go stag sometimes."

Jimmie Cooper, "Memphis World Inquiring Reporter."

Memphis World,
21 August 1953, 6.
RS2006.2.53

A simple question posed by Jimmie Cooper, a "Memphis World Inquiring Reporter," provided several people with an opportunity to talk about the local entertainment scene. Of the five interviewed, three expressed concern that the order would prevent them from patronizing nightclubs. The question was part of an occasional feature in the summer of 1953. Other questions included "what do you think should be done to make Memphis a better place to live?" (4 August), "what can be done to secure better housing for negroes in Memphis?" (7 August), and "why do you read negro newspapers?" (14 August). Cooper, who also wrote the columns "Beale Street is My Beat" and "Police Beat," provided *Memphis World* readers with access to the voices and experiences of those men and women who otherwise might not have been encountered in the pages of the paper.

The photograph of George Johnson finds him in a Hawaiian shirt and tortoiseshell sunglasses, frankly regarding the photographer who accompanied Cooper on his informal polling of individuals on South Main and Beale Streets. When linked with his casual demeanor, the slight turn in Johnson's head captures the fleeting nature of this encounter while anchoring it in a moment, and context, from the summer of 1953. Given the history of segregation through the control of dance halls and nightclubs, Cooper's inquiry about the potential effects of a police order nonetheless was clearly linked to the broader politics of regulating the lives of Memphis residents in the age of Jim Crow.
DMcC

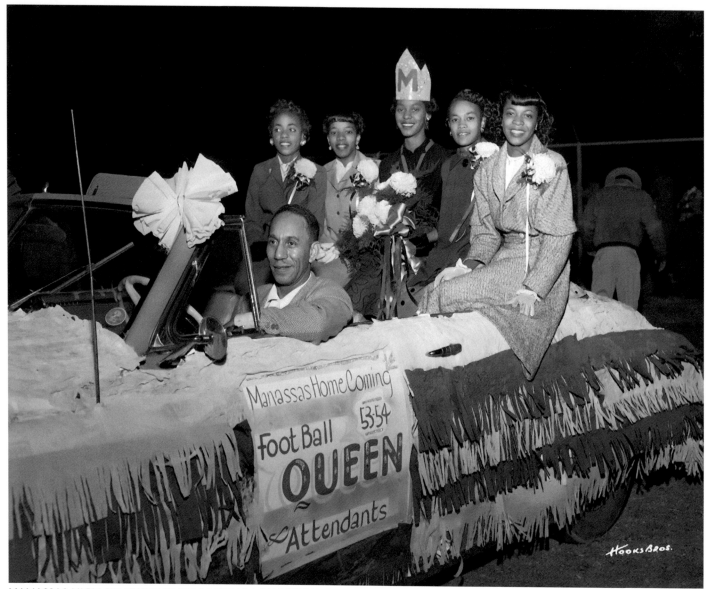

MANASSAS HIGH SCHOOL'S QUEEN BARBARA HARRISON IS SEEN SEATED WITH HER ATTENDANTS—(left to right)—Miss Geraldine Williams, Miss Lula Black, Miss Armelia Wilson and Miss Barbara Hobson. Driving the float is Mr. Walter P. Guy, Jr., instructor of Art at Manassas.

Memphis World, 1 December 1953, 2.
Photograph by Hooks Brothers Photography.
2006.31.87

Also published: *Tri-State Defender*, 5 December 1953, 11.

Manassas High School produced, and continues to produce, a long list of accomplished students who have graduated from nationally recognized institutions such as Harvard, Yale, Bryn Mawr, Notre Dame, and most of the Big Ten schools. They benefited from dedicated educators such as Principal J. Ashton Hayes, who was appointed in 1929 and served twenty-four years. Ashton, who adopted the motto "The Best Is None Too Good For Manassas," oversaw the construction of a new building that opened in 1938, with an addition encompassing a library, cafeteria, and two science rooms in 1953. Competitive sports were introduced in 1924, including the first Negro football team in the city, followed by baseball and basketball.

Despite its 2-3 record, Manassas played 4-1 Booker T. Washington High School (BTW) in the 1953 Blues Bowl. Founded in 1939, the event included a parade from the fairgrounds to the Melrose High School field; a tribute to W.C. Handy, who also played; fireworks; and a halftime program that included a tribute to Nat D. Williams, a founder of the event. Barbara Harrison, pictured here in the earlier homecoming parade, also rode with her entourage to the bowl in a float sponsored by the *Commercial Appeal*. Manassas scored a touchdown and safety late in the game to beat BTW 9 to 6.
MP

COMMUNITY VOICES

Daddy decorated all of the floats and cars for all the parades at Manassas. This was a Manassas homecoming. This float is very minimalist compared to the ones that I remember which were covered with yellow chrysanthemums, blue ribbons—the gold and blue emblem of Manassas. So this is low-budget for him, this float right here. That's not anything compared to what I remember hiim doing later on.

Francine Guy, interview with Marina Pacini, Memphis, TN, 3 Jul 2008.

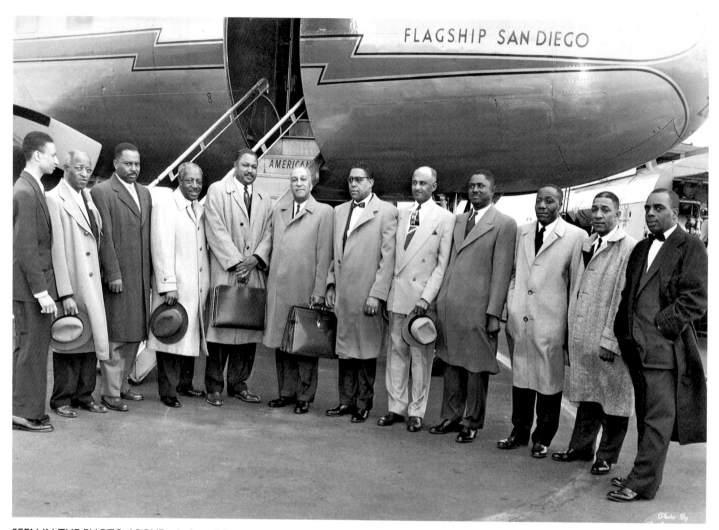

SEEN IN THE PHOTO ABOVE—Left to right: are the Men's Day committee of St. John Baptist church, at the airport . . . James Pulliam, Prof. W.L. Pamplett, Dr. W.L. Pippin, T.L. Lumpkin, Atty. J.F. Estes, Atty. J.R. Booker, (speaker), S. Martin, B.L. Clark, J. Smith, R. Sims, H. Smith, Prof O.L. Cash.

Memphis World, 9 March 1954, 2.
Photograph by R. Earl Williams.
2006.31.83

A group of eleven laymen stand in a semicircle before an airplane at the Memphis Airport. They braved the winter cold to meet J.R. Booker, a prominent lawyer from Little Rock. A member of the Arkansas State Advisory Committee of the Federal Civil Rights Commission and active in civil rights cases throughout his lifetime, Booker was eulogized by Thurgood Marshall in 1960. In their placement and pose, the men pictured unify the photograph visually, while their influence brought strength to their community.

J.F. Estes and T.L. Lumpkin were notable figures in the postwar era. Attorney Estes served on the Memphis Committee on Community Relations, an integrated group of professionals dedicated to ending segregation in public institutions such as the Brooks Memorial Art Gallery. Estes also served as a lawyer for the local chapter of the NAACP. Given the traditional place of honor to the visiting speaker's right, his imposing stature suggests his importance to the *Memphis World* readership. T.L. Lumpkin, next to Estes, owned a successful barbershop, and by 1946 had worked his way up from a shoe-shine boy to assume one of the first two positions allocated to African Americans by the Associated Master Barbers and Beauticians of America. Lumpkin founded a barber college for servicemen. By 1949, he had gained enough distinction to be elected king of the Memphis Cotton Makers' Jubilee.

Together, these eleven distinguished men embodied the ideals of the *Memphis World*. They were active members of their church and their community, and through their participation they perpetuated a positive example of civic engagement.
EW

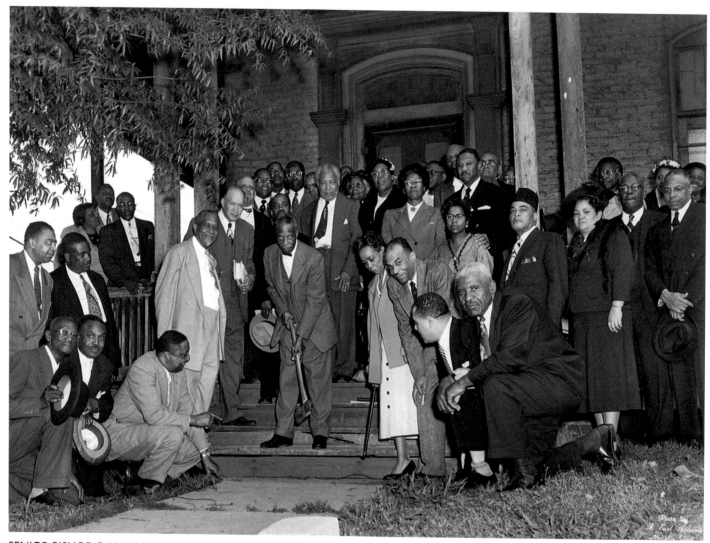

SENIOR BISHOP C. H. MASON (center) holds the ax ready to commence destroying the steps on the spot where the future home of the Church of God in Christ Publication House, will be erected while Overseer F. D. Washington, president of National Publication Board points to spot where the ax should strike the first blow to demolish the present structure.

Mother Lillian Brooks Coffee, holds the crow-bar as a sign that all women are ready to begin action on the great project which has been the dream of the organization for more than a quarter of a century to consolidate all of the publications of the church. Others shown are: Overseers L.C. Patrick, vice president; L.H. Ford, 1st vice-president; M.O. Mason, secretary; Bishops J.O. Patterson, treasurer and A.B. McEwen, chairman of Board of Directors.

Overseers C. Parker, C.C. Cox, C.A. Ashworth, W.L. Morris, A.A. Childs. Bishops O.T. Jones, W.G. Shipman, J.S. Bailey, C.L. Anderson, V.M. Barker, W.J. White, T.D. Igelhart, T.L. Young, C. Range, I.G. Glover, J.D. Myles.

Mothers A. McKenzie, McGregor Jones, and A. Jackson. Others are Mrs. Eva Sparks and Supt. J.L. Lewis.

Memphis World, 20 April 1954, 1.
Photograph by R. Earl Williams.
2006.31.82

In 1895, Bishop Charles Harrison Mason formed alliances with other religious figures, including C.P. Jones of Mississippi and J.A. Jeter of Arkansas. Together, these men delivered sermons in living rooms and abandoned warehouses across Memphis; their activities provided the grassroots foundation for the Church of God in Christ (COGIC). Since then, the church has become the fastest-growing Pentecostal organization in the United States with approximately 5.5 million members.

Arranged along the porch and front lawn, the overseers and board members of the church completely fill the frame. A pool of space separates Bishop Mason, thus distinguishing him from the surrounding people. Furthermore, the sidewalk leads straight to the bishop, revealing him to be the clear centerpiece of this photograph, thereby echoing his centrality in the machinery of the church. CC

COMMUNITY VOICES

He [R. Earl Williams] was the photographer for the Church of God in Christ, Incorporated. Bishop Patterson had known my brother ever since he had been in church and he knew Earl was a photographer. And he had an almost-life-sized picture in the sanctuary of [Bishop Mason] that Earl did, and he liked this picture so he got with him and told him he wanted the founder of the denomination in every church. He and my brother got together and he had to make them for the entire denomination.

Earline Williams Nelson, interview with Marina Pacini, Memphis, TN, 24 April 2008.

BISHOP J.O. PATTERSON, Pastor of Pentecostal Temple, crowns Queen Sharon Rebecca Lewis and King Joseph Lee Nelson as Junior King and Queen of the year.

Queen Lewis is the daughter of Mr. and Mrs. Ruth and Robert Lewis Jr., (Mr. and Mrs. R.S. Lewis Jr.), owner and managers of Lewis and Sons Funeral Home, Vance Avenue with King Joseph Lee Nelson, the son of Mr. and Mrs. Joseph Nelson, Sr., Manager of the William E. Foote Homes Housing project.

The Main purpose of the contest was to get the children interested in working for the church and its activities. They will be given a twenty-five dollar Savings Bond, or a bank account of equal amount.

Not shown in the picture are Prince Bruce Brownlee and Princess Denise Beasley.

Memphis World, 23 April 1954, 1. Photograph by R. Earl Williams. RS2006.2.73

Pentecostal Temple's queen appears slightly more secure beneath her lopsided crown than her hesitant king. The children are likely holding hands behind the bell of the queen's skirt, supporting each other before the watchful gaze of the church's congregation. The sheen from the varnished floors, the stark white cloth draped over the table, and the polished candelabra contribute to the imposing atmosphere. Stabilizing the crowns and centered in the photograph is Bishop J.O. Patterson, his trim mustache echoing a gentle smile. His calm gaze and relaxed presence offer a confident backdrop for the small children.

Born in Delma, Mississippi, on 12 July 1912, James Oglethorpe Patterson started his working life as a shoe-shine boy and a clothes presser. In 1934, he married Deborah Indiana Mason, daughter of Church of God in Christ (COGIC) founder C.H. Mason. Patterson began his ministry in 1936. Upon Bishop Mason's death in 1961, Patterson was named head bishop of COGIC, a position he held until 1989. Under his guidance the church grew to over four million members in more than forty countries. Patterson stood behind the church as a visionary leader for nearly thirty years and guided its growth as it became the largest African American denomination in the world.
AS

COMMUNITY VOICES

I remember there was some kind of contest [at the church]. . . . I don't look very happy here. For some reason, my mother tells me, I used to beg my uncle [R. Earl Williams], not to take my picture. I don't know why. So maybe that is why I'm looking the way I do there. I feel great about this picture because the church was such a big part of the history of this city. I'm not sure if it was maybe twenty or twenty-five years after this there was a reunion of the king and queen, . . . it was unbelievable because they did it on one of the riverboats, so here we are going down the river this huge choir is up there, organ, piano, drums, the whole thing, rocking and singing. It was an amazing sight.

Joseph Nelson, interview with Marina Pacini, Memphis, TN, 18 April 2008.

They had that contest to raise money for the building funds. They had six girls and six boys and they raised the most money and won. . . . They would let them know that they were trying to be the baby king and queen of the church, and people just gave them money. Joseph's great-grandmother was very busy in the neighborhood trying to sell votes. She was so proud of him, she wanted him to win. . . . Of course we were very proud he won. He didn't think too much of it. You can tell from the picture, because at that time he'd gotten to the place where he didn't like to have pictures made. I think it was the flash that he didn't like. He didn't want to have that made that day, I had to kind of force him.

Earline Nelson, interview with Marina Pacini, Memphis, TN, 24 April 2008.

PARENTS AND RELATIVES OF THE FORTHCOMING GRADUATES of St. Anthony High pose with prospective graduates during a luncheon given to the students' honor by their parents. Standing (left to right): Mrs. L.B. Robinson, Miss Sylvian Albritton, Mrs. Meekins, Mrs. Davis, Alexander Dumont, agency director of the North Carolina Mutual Insurance Company who was guest speaker at the luncheon, Mrs. Wallace, Mrs. Richmond, Mrs. F.P. Morris, Mrs. Thomas and Mrs. L. Pipes. The prospective graduates are (seated from left to right): Mildred Robinson, Onnie Mae Culp, Carolyn Kirk, James Jones, Florine Richmond, Bertha Jean Morris and Adaline Pipes.

Memphis World, 21 May 1954, 3.
Photograph by Ernest C. Withers.
2006.31.34

To document this special occasion for Memphis's competing newspapers, Ernest Withers took multiple shots, which, despite being taken from the same location, are quite distinct. For the *Tri-State Defender*, the seated students and the invited speaker—the sole adult— standing at the head of the table are posed in a highly formal arrangement. In contrast, for the *Memphis World* the honorees appear in a semicircle surrounded by their proud families. The latter is a much more celebratory image because of the sheer number of participants in their festive hats, outfits, and corsages, as well as the greater attention given to the luxurious surroundings of the Lumpkin Hotel.

Among the students is Mildred Robinson, who also appeared in the *Tri-State Defender* on 22 May crowning a statue of the Virgin Mary as part of her duties as the May Day Queen of St. Anthony Church. On 12 October 1909, the Feast of St. Anthony, the building at Hill and Corcord Streets that housed both the Catholic school and the church was blessed and dedicated. Established for African American students and run by the Sisters of Charity of Mount St. Joseph, the institution was turned over to the Sisters of Charity of Nazareth, Kentucky, in 1941. High school classes were added in 1940. When a new church was constructed in 1942, the chapel was turned into an assembly hall and additional classrooms. St. Anthony later merged with St. Augustine Church.
MP

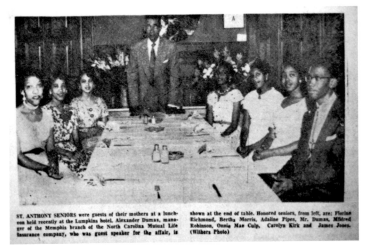

ST. ANTHONY SENIORS were guests of their mothers at a luncheon held recently at the Lumpkins hotel. Alexander Dumas, manager of the Memphis branch of the North Carolina Mutual Life Insurance company, who was guest speaker for the affair, is shown at the end of table. Honored seniors, from left, are: Florine Richmond, Bertha Morris, Adaline Pipes, Mr. Dumas, Mildred Robinson, Onnie Mae Culp, Carolyn Kirk and James Jones. (Withers Photo)

Tri-State Defender, 29 May 1954, 2nd section, 9.

COMMUNITY VOICES

What was it like at St. Anthony? Strict. You did your work you had no problems. [The nuns were] very, very patient. A poor lunch, we had no cafeteria. . . . I went off to college . . . then came [back] to Memphis. That's when I found—St. Anthony's been closed. And it was like somebody stabbed me in the back. How could St. Anthony's be closed? Well, there was this priest and he closed St. Anthony and moved to Breedlove or some street in north Memphis, he saw no need to keep it open. . . . Why did St. Anthony close? Because the priest didn't know what to do, he was in a black neighborhood, I guess enrollment was down, he didn't know how to get it up or he didn't know what to do. . . . But when they closed St. Anthony's that to me was a tragedy. I couldn't believe this. When I left St. Anthony [1952] and went to St. Augustine in 12th grade, man was I misguided. . . . When I got over there, I was head and shoulders above those kids in every respect. So I kept quiet because I didn't want them to know how smart I was. . . . St. Anthony, they did fine with me. I could have learned more, I didn't understand how much I was getting, I didn't realize how much they were putting in.

David Wright, interview with Marina Pacini, Memphis, TN, 18 December 2007.

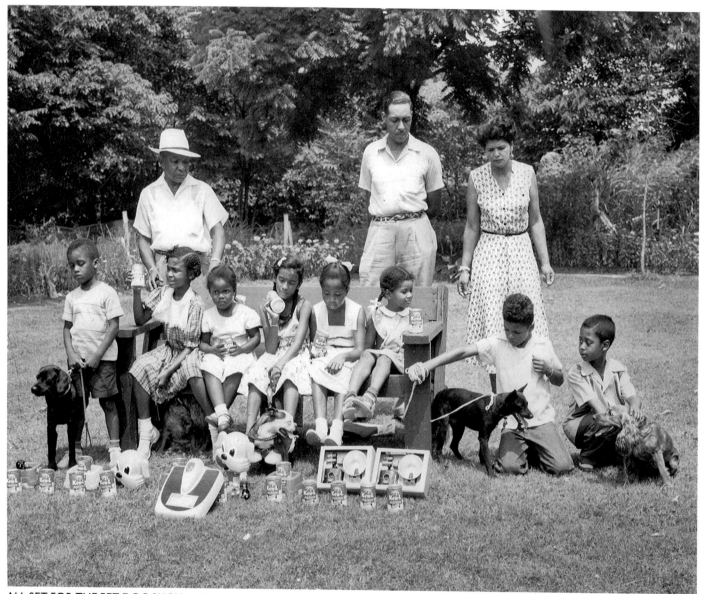

ALL SET FOR THE PET DOG SHOW. . . Shown here from left William A. Stevenson, Geraldine Lynom, Susan Stevenson, Edna Louise Jones, Yvonne Roulhac, Chris Roulhac, III, and W.O. (Bill) Speight, III. In background is Prof. J. L. Brinkley, Jr., Dr. W.O. Speight, Jr., and Mrs. Nellie Roulhac, Jr., newly elected president of the National Jack and Jill Club.

Memphis World, 9 July 1954, 7.
Photograph by Clarence Blakely.
2006.31.102

The Memphis Jack and Jill Club was founded in 1946 by local parents, Nellie Roulhac and Alma Roulhac Booth among them, who wanted their children involved in constructive social activities with youngsters of similar backgrounds. The adults were attracted to the club's emphasis on parental involvement in child development—an emphasis that persists today as a guiding principle of the national organization. Nellie Roulhac was elected national president of the club earlier in 1954. The lawn of her South Barksdale home provides the setting for this photograph.

Parents and children gather with dogs and prizes prior to the annual show. Although the image is composed much like a formalized group portrait, none of the participants looks at or poses for the camera. Instead, their attention is diverted as one dog looks off into the distance, another seeks shade under the bench, and two others look toward Chris Roulhac's dog, which, in the most canine of fashions, wraps its leash around the leg of the bench. In disrupting the photograph's formality, the dogs naturally steal the show. RT

COMMUNITY VOICES

Have you ever attended a dog show? Then you should have attended the Jack and Jill Dog Show held Saturday, July 10, at the Hippodrome.

Dogs of every description, long haired, short haired, bob-tailed, spotted and what-have-you took their places in the line of judging and many walked away with choice prizes and ribbons.

The affair was co-sponsored by Unity Cash Grocers and the Quaker Oats company, makers of Ken-L-Biskit dog food.

Master of ceremonies for the occasion was Publisher L.O. Swingler who introduced the local Jack and Jill president, Mrs. Helen Hooks and Mrs. Nellie Roulhac, national president. The Memphis Letter Carriers Band under the excellent leadership of M.W. Thornton, jr., provided music for the occasion. Everyone enjoyed it including the dogs who perked up as the tempo increased.

From "Award Choice Prizes Ribbons At Dog Show," *Tri-State Defender*, 17 July 1954, 5.

Well, Jack and Jill, it was national. I recall being in Jack and Jill just about till the time I went away to prep school. . . . Jack and Jill to a large extent to me was just the kids of the people my folks ran with. . . . We did grooming types of things. On the older age, I remember my first date/dance—take the corsage, pin it on the girlfriend—was a Jack and Jill setup. They had a dance over at LeMoyne-Owen College basically to teach us how to go through that ritual.

Rashad Sharif [W.O. Speight III], interview with Rachel Touchstone, Memphis, TN, 19 January 2008.

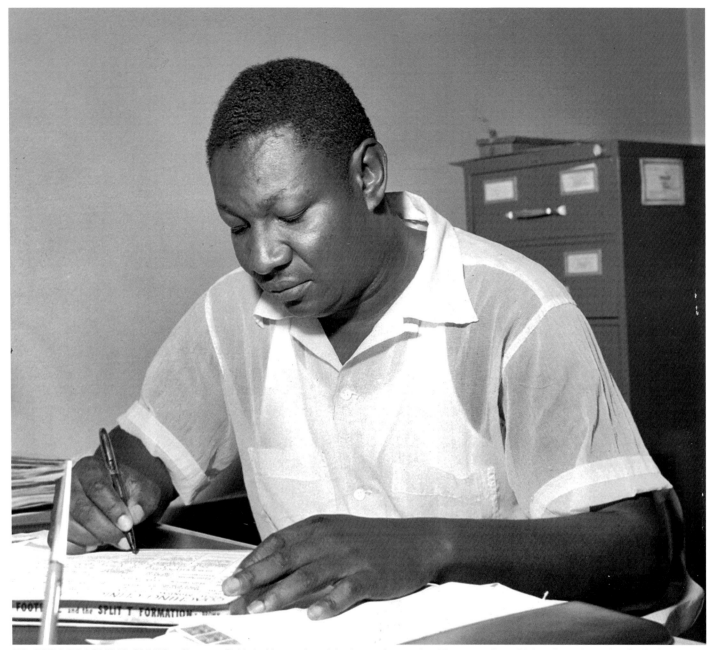

TO OPEN COACHING CLINIC—Shannon D. Little (shown above), junior varsity coach at Tennessee State University as he makes final adjustments on his program for the football coaching clinic to convene on Tennessee State's campus August 16-21.

Memphis World, 10 August 1954, 5.
Photograph by P. Cuff.
2006.31.13

Trade portraiture, imagery that depicts the sitter's identity as intimately connected to his career, has a history extending from at least the 16th century. Essentially an advertisement for the upcoming coaching clinic, this photograph shows Shannon Little as a football coach. He is seated in the office where he designed plays for his team and discussed strategy with his staff. The setting is made complete by the files scattered on the desk and the filing cabinets in the background that together imply his vast knowledge of football. This is reinforced by the book labeled "football" and "split T formation." Little's football wisdom gave him the background he needed to become one of the most productive recruiters in the university's history. His experience both on and off the field helped him become an influential coach and educator.

Leadership within black communities was not limited to the social elite. Images of accomplished men provided a counterpoint to racist assumptions about African Americans. As opposed to a studio portrait, which would emphasize the specificity of his facial features, Little's visage is not central to the photograph; he does not acknowledge the camera. Instead, his concentration visually suggests his love for the sport and dedication to his job.
EW

COMMUNITY VOICES

Shannon Little came to Tennessee State in 1944 and gained 1st All-American honors. Tennessee State was 36-5-1 during his playing days as an offensive lineman blocking for All-American quarterback Nathaniel Taylor. As a Tennessee State football coach from 1951 to 1974 he was considered one of the most consistently successful recruiters in the history of TSU. He was TSU director of personnel, chief scout, and end and linebacker coach for the Big Blue Tigers. He personally recruited such notables as Eldridge Dickey, Claude Humphrey, Waymond Bryant, Ed "Too Tall" Jones, and Vernon Holland just to name a few. Coach Little also scouted the Tiger's opponents so well that many TSU victories were credited to his scouting. He is a noted lecturer and writer on physical education and sports.

Tennessee State University press release, 1984, Archives, Tennessee State University, Nashville.

GEORGE B. TURMAN, first Civil Aeronautics Administration inspector, mechanics examiner, and aircraft maintenance instructor in this area, returned to the faculty of Tennessee State University on December 1.

Memphis World, 14 December 1954, 2. RS2006.2.13

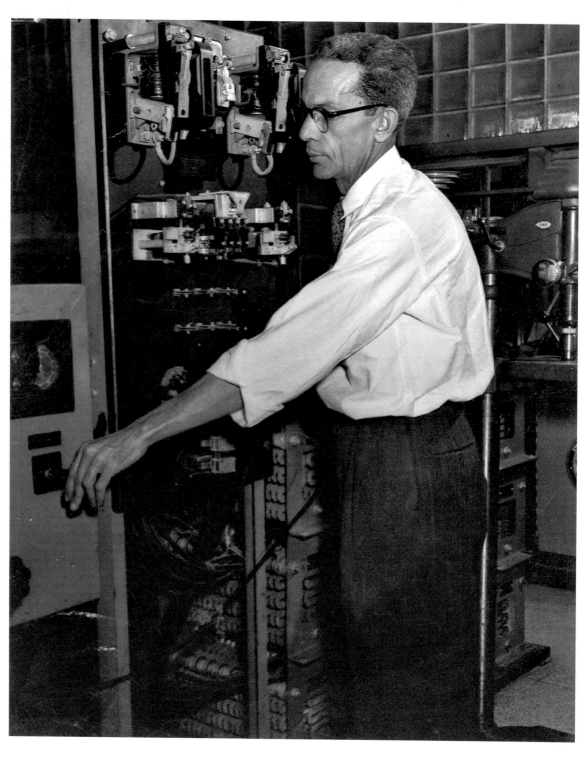

The Civil Aeronautics Administration (CAA) was developed in 1940 when President Franklin Roosevelt split the Civil Aeronautics Authority into two separate sections, the CAA and the CAB (Civil Aeronautics Board). The CAA was responsible for air traffic control, airway development, and safety protocols. Before World War II began, the CAA developed the Civilian Pilot Training Program. Later, the CAA began to operate airport control towers, and during the postwar period began administering a federal program aimed at promoting the development of the country's civil airports.

George B. Turman became a worker for the CAA during the Jim Crow era. He stands, studiously at work, brow furrowed, inspecting machinery. He is wearing a white dress shirt and tie. Due to the nature of his job he is not engaged in manual labor, which during that time was the norm for people of color. On all sides he is framed by the necessary components of his occupation, the machinery. Not focusing on the camera or the photographer, he continues to show his professionalism in conducting his job.
LW

COMMUNITY VOICES

On leave to do special work in aeronautics as a superintendent of maintenance, and as a CAA designed aircraft maintenance inspector and mechanics examiner. Mr. Turman recently completed the electronic pilot course sponsored by Lear, Inc. He participated in a 3-day operation which set up a schedule air freight line for top priority government shipping which now extends from coast to coast and into Greenland.

At the present time, Mr. Turman is the only licensed auto-pilot technician in a six-state area including Tennessee and Indiana. He is a specialist in the installation, maintenance, and repair of the electronic, automatic pilot.

Since January he has been with Capitol Airways, Inc., as superintendent of communications—radio and electronics. In addition he has continued his CAA duties. He holds a radio operator certificate and is a product of Tennessee State.

Memphis World, 14 December 1954, 2.

FAMOUS PARISIAN MODEL—Dorothea Towles will introduce Memphians to some of the latest in international and national fashions at a show set for Tuesday, April 5, in Ellis Auditorium sponsored by local Alpha Kappa Alpha sorors.

Memphis World,
11 March 1955, 1.
Photograph by Irving C. Smith.
RS2006.2.37

Beautiful and talented, Dorothea Towles made her living as a model. Pictured with long dangling pearl earrings and an evening hat accented with feathers, she represented European high style of the postwar period. She was renowned for changing her hair color, an impressive feat for the modeling industry at the time. Appearing in such magazines as *Ebony* and *Jet*, Towles was an international celebrity.

Towles was born 26 July 1922 in Texarkana, Texas, the seventh of eight children of a farming family. The first black woman to attend the Dorothy Farrier Charm and Modeling School in Los Angeles, California, she began her career by taking jobs that catered to black audiences. By 1950, she was in Paris modeling for such highly recognized designers as Christian Dior, Pierre Balmain, and Elsa Schiaparelli. While abroad, she bought haute couture items not for herself, but to showcase to black communities in the United States that had little, if any, access to this type of fashion. On her return to America in 1954, she began to tour black colleges. Many of her appearances were sponsored by the Alpha Kappa Alpha sorority. The Memphis fashion show, titled One Night in Paris, was organized to display Miss Towles's wardrobe, bring fashion to the city, and raise funds for scholarships for local high school students.
LW

COMMUNITY VOICES

Dorothea Towles was an AKA, and she used to model. I met her once in Washington, D.C., when the AKAs were meeting. We were at this girl's house, and Dorothea came in wearing a suede suit, at that time nobody had heard of a suit made out of suede. She was tall, slender, just shapely. And she'd cross her legs, and everything matched up. She was just every last word. We did have her come to Memphis to model for a fund-raiser for AKA. . . . Along with the principal person who was featured, the local models would be wearing their own clothes.

[We went to] Goldsmith's to buy clothes, and for better things we went to Levy's at the corner of Union and Main, that's where your high price things were. . . . They always told us Gerber's didn't want you. But, I never had trouble with Gerber's. I do know that they would make you go in the back to try on hats. At Goldsmith's you couldn't eat in the dining room, but you could eat downstairs in the basement where the maids and all ate. . . . But now, Goldsmith's actually cashed all the teachers' checks, so Goldsmith's was always very cordial, the clerks there treated you nicely. At Goldsmith's and Levy's, [you] had to go in the back to try on the hats, you couldn't go to out front [to try on clothes]. Well, I think you sort of get adjusted to a situation. You know it's not right, but you know just like sitting on the streetcar, you go to the back of the bus, and it seems as if even after integration, you still went to the back of the bus because you were in the habit of going there.

Alma Roulhac Booth, interview with Marina Pacini, Wyncote, PA, 11 October 2007.

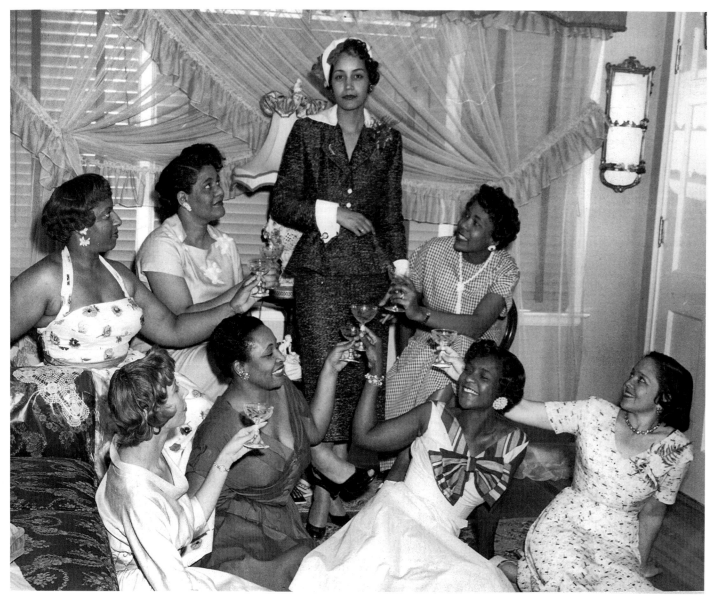

MEMBERS OF LA MAR CHERIE CLUB HONOR "QUEEN MARY BEALE," AND HER KING GEORGE ROBINSON AT BRUNCH—Seen left to right (front) are Mrs. Marcellus Durham, Mrs. Robert Robertson, Mrs. Howard Chandler and Mrs. Helen Brittenum. Back: Mrs. Mabel Winford, Mrs. Frances Starks, Queen Mary Beale who reigned over the Cotton Makers' Jubilee last week and Mrs. Earline Hampton as they enjoyed the morning at the lovely Evergreen Gardens home of Mr. and Mrs. Robert Robertson.

Memphis World, 20 May 1955, 4.
Photograph by Coleman Photo Service.
RS2006.2.25

Mary Beale owned Beale's Gift Shop on Mississippi Boulevard, and was also a professional model and charm expert. George Robinson, a retired army major who was a veteran of both World War II and the Korean conflict, was a biology teacher at Manassas High School. A 21 May 1955 article in the *Tri-State Defender* details their duties as the queen and king of the Memphis Cotton Makers' Jubilee. "Their hilarious week" began with a brunch hosted by the La Mar Cherie bridge club on Sunday, 8 May. In this photograph, Queen Mary stands in her chic suit and hat surrounded by her fellow members. The elegant ladies are posed casually and toast her reign with champagne.

The hectic week continued. Monday, coronation of the Junior King and Queen. Tuesday, their coronation at Martin Stadium followed by a cocktail party hosted by members of Top Hat and Tails, and the Coronation Ball. Wednesday, visits to Manassas and Douglass High Schools and Veteran 88 Hospital, lunch sponsored by the YW Wives of the Vance Avenue YWCA, and a tea hosted by the Gorine Beauty College. Thursday, visits to Melrose, Hamilton, and Washington High Schools, lunch in their honor at Universal Life Insurance Company, the Zo-Zo Club's Masquerade Ball, and the Blue Notes Social Club Dessacatee Formal Ball at Currie's Tropicana Club. Friday, reviewing the children's parade, dinner hosted by the Dentists' Wives at the Gay Hawk Restaurant, and joining in the Grand Jubilee Parade until they arrived at the Handy Park reviewing stand to watch the rest of the procession along with their Royal Court, before the culminating Grand Jubilee Ball at the Beale Avenue Auditorium.
MP

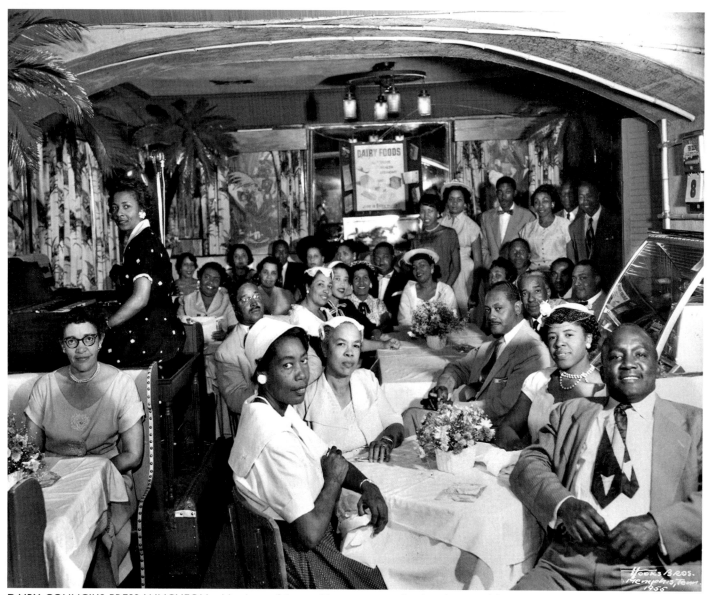

DAIRY COUNCIL'S PRESS LUNCHEON—Members of the working press were feted at the annual Press, Radio and Television luncheon given recently by the Memphis Dairy Council at Tony's Inn. This month, June, is being observed nationwide as "Dairy Month" and the press guests shown above were treated to a repast featuring many dairy products.

Mrs. Francis Crain, council director, showed a film which represented an annual report of the council's activities and Mrs. Leoda B. Gammon (first left, seated), council nutritionist and contributing columnist to the Memphis World, was hostess.

Memphis World, 17 June 1955, 4.
Photograph by Hooks Brothers Photography.
2006.31.132

The three-panel display board on the back wall in this photograph features the central theme of the press luncheon: dairy foods. Since 1931 the Memphis Dairy Council's dentists, dietitians, and health experts had encouraged black Memphians to eat well. The afternoon was spent lauding the successful efforts of local teachers in developing innovative strategies designed to teach healthy living to their students. Farm agents, YMCA staff, and hospital workers learned that the council's school lunch program was more nutritious than most home-cooked meals. The guests heard that in 1953, third graders from Hamilton Elementary visited a dairy farm, sixth graders at Carnes Elementary completed a science experiment called Taking Milk Apart, and Douglass Elementary students practiced bodybuilding. The educators were applauded for their success in making health fun.

The gentility of pearl necklaces and knotted neckties; netted and wide-brimmed hats; starched shirts; and sports coats reflects the importance of the event for attendees. Warm smiles indicate that they may have seen the day's menu: T-bone steaks, English peas surrounded by creamed potatoes, hot buttered rolls, peach salad, cottage cheese, and milk. Dessert was a pastry shell filled with ice cream. This standing-room-only assembly shows that a healthier Memphis requires a community effort.
AS

MRS. JULIAN (JOHNETTA WALKER) KELSO is seen making contributions to Atty. Thurgood Marshall, NAACP lawyer for members of the Memphis Links, Inc. at a Public Meeting held at Metropolitan Baptist Church last Thursday evening. Mrs. Kelso is past president of the Memphis Links, Inc.

Memphis World, 10 February 1956, 1. Photograph by Ernest C. Withers. 2006.31.48

Thurgood Marshall had a remarkable career fighting for equal rights for minority groups. From 1940 until 1961, he served as the chief council to the NAACP, successfully arguing twenty-nine cases before the Supreme Court. This visit to Memphis came two years after his landmark victory in *Brown v. Board of Education* (1954), which put him on track to becoming the first African American to serve on the Supreme Court. Although her accomplishments were on a local scale, Mrs. Johnetta Walker Kelso was also dedicated to enriching the lives of African Americans. Her family founded numerous institutions in Memphis, such as the Universal Life Insurance Company (ULIC), the Tri-State Bank, and the Mississippi Boulevard Christian Church. She served on the board of directors for the ULIC; held lifetime memberships in Alpha Kappa Alpha Sorority, Inc., the YWCA, and the NAACP; and was also instrumental in establishing a Memphis chapter of The Links, Inc.

In this photograph, two prominent figures converge in a visual affirmation of the black community's dedication to ending segregation. To many Memphians, Mrs. Kelso represented the finest of black Memphis (notice that the caption includes her maiden name, whereas most women were identified solely by their husbands' names), so it seemed fitting that she should greet Attorney Marshall during his visit. The informality of their exchange is in marked contrast with the tenor of his rousing speech, delivered on 9 February at the Metropolitan Baptist Church.
CC

COMMUNITY VOICES

For the life of us, we can't see what the other side has to go on. We have the law, religion and God on our side. Maybe the opposition will get tired of putting all faith and hope on the devil. He never stayed with anybody. He's the only one they have to rely on.

We have got the other side licked. The only way they can be successful is to split us down the middle. They are going to try it! They will say our leaders are bad, that we don't have money. They are trying to pass laws to fine us $5 for a $2 subscription. They are suing us for the libel and slander. Fools they are, they think they can divide us or get all our money!

We are going to meet them in every back alley and cross road. We are going to carry them to the Main Street. There is no doubt when it is all over that the umpire, which is the Supreme Court, will say: "You're still out!"

Everyone is invited to go down the road with us. With the law on our side, God on our side, who worries about anyone else?

Thurgood Marshall, 9 February 1956 speech excerpted from L. Alex Wilson, "2000 Hit 'Storm' to Hear Marshall," *Tri-State Defender*, 11 February 1956, 1-2.

MR. AND MRS. KENNETH WHALUM seen cutting their wedding cake at a reception given at the Whalum home by the bride's parents, Mr. and Mrs. Square Marshall. Mr. Whalum is the son of Mrs. H. D. Whalum, Sr. and the late Mr. Whalum of the Union Protective Assurance Company. . . The groom is a clerk at the Main Post Office here. . . The pretty bride, who has made her home with her grandmother, Mrs. Callie Franklin, is a student of LeMoyne College. . . The couple will be at home at a new apartment joining lots to the Whalum's Neptune residence.

Memphis World,
25 May 1956, 3.
Photograph by Hooks Brothers Photography.
RS2006.2.19

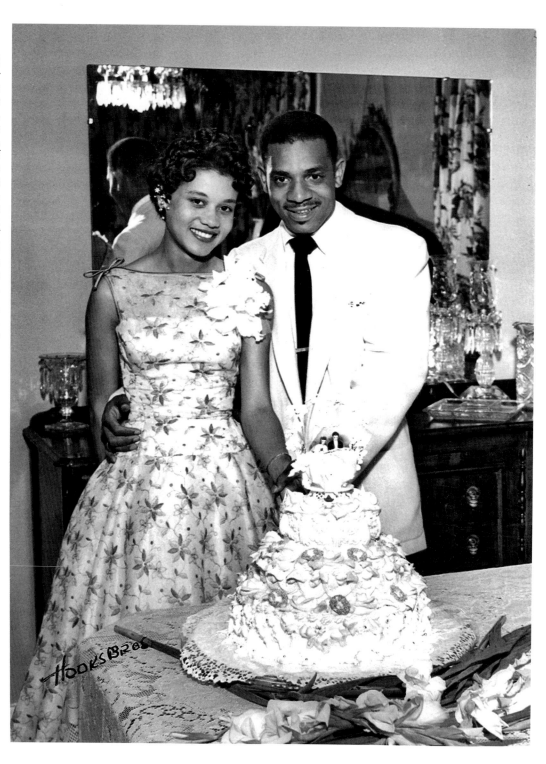

On 10 September 2007, the post office at 555 South Third Street was renamed the Kenneth T. Whalum Senior Post Office Building. During his tenure Whalum rose from a postal clerk to director of employee relations for the southern region, a position unheard of for a black man in the Jim Crow South. Born in 1934, Whalum served in the U. S. Navy from 1950 to 1954, and in 1969 he entered the ministry. He served as a city council representative for the Orange Mound community from 1988 to 1996, and pastored the Olivet Baptist Church until 1999.

Like most couples, Kenneth and Mary Helen Whalum began their marriage with the simple ceremonial task of cutting the wedding cake. The cascaded tiers of the cake draw the eye to the peak, where two plastic wedding figures echo the couple. Ironically, the white figurines provide a figurative representation of this black couple's marriage. Crystal candleholders decorate a shining wooden sideboard, a sign that the groom's parents were relatively affluent. Set against a stark white suit, Whalum's black tie is a bold streak that directs attention to his casual smile. The photograph documents a joyous moment at the beginning of a marriage that produced three noted children—Dr. Kenneth Jr., Kirk, and Kevin—familiar to most Memphians.
AS

COMMUNITY VOICES

Their father taught them to cook, to love the Lord and to devote their lives to Jesus—in and out of church.

"All three of them grew up right behind me," Whalum Sr. said. "They enjoyed church, not that they had any choice."

David Waters, "Praise Be: The Brothers Whalum," *The Commercial Appeal*, 19 February 2007, A1.

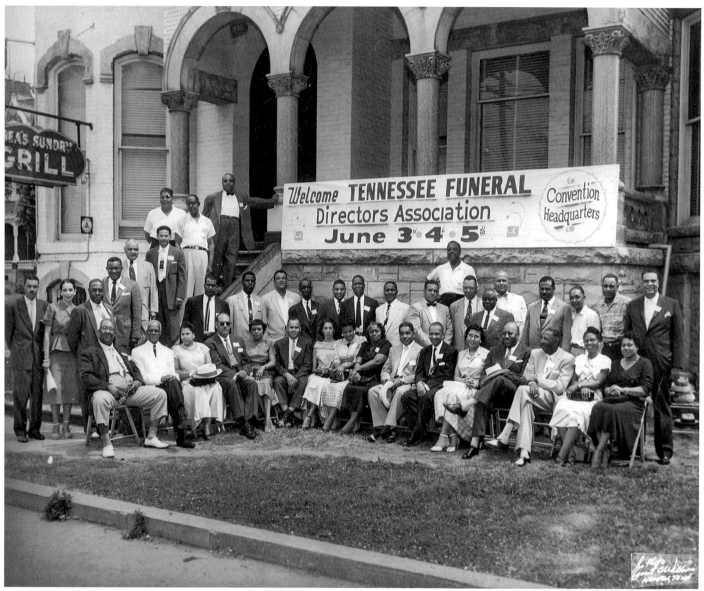

BLUFF CITY FUNERAL DIRECTORS are hosts to Tennessee Funeral Directors Association - June 3, 4, 5, with headquarters at the Orleans Hotel, with Mr. Hobert Martin, State President, presiding over sessions. . . Mr. N.J. Ford is president of the Bluff City group of Morticians.

Memphis World, 15 June 1956, 1.
Photograph by Ernest C. Withers.
2006.31.115

Funeral directing has traditionally been a stable profession in Memphis's African American community. It was an enterprise that served as an economic cornerstone for the community. Some of the most popular black funeral homes included T.H. Hayes and Sons, the first black funeral home in Memphis; R.S. Lewis, which handled the funeral of Dr. Martin Luther King Jr.; and Southern, Victory, and Qualls funeral homes. From the directors' dress it is evident that this was not blue-collar work. The forty-one men and women posed for the photographer helped to facilitate an essential process and guaranteed that the deceased would not suffer discrimination during their last public moments.

The family atmosphere of black funeral homes helped earn them the public's trust. Some directors moved into religious and political professions. For example, the famous Patterson family of Memphis owned J.O. Patterson Funeral Home long before heading the Church of God in Christ, one of the country's largest denominations. The Ford family political dynasty sprang from its South Memphis business.
CW

COMMUNITY VOICES

Whites weren't burying us, so someone had to bury us. The funeral director had to be a "people person" and have charisma. He was called to organize everything—the family, preacher, and get into contact with all the people. He had to be skilled and likable. It was not an easy job, but the profession is not going anywhere because it is a people business. The funeral business has been important to the community because it established a bond. We bury a father, if we handle business as we should, later we bury the mother, sisters, and so on. The business is about helping people in their time of need—some people who never get helped. Back then, whites wouldn't give them the help.

Black funeral homes were definitely economically beneficial to the community. They hired other part-time workers. One family owned funeral home owned a professional baseball team. Black funeral home businesses used their knowledge to get involved in banking, investments, real estate, insurance, and car lots, anything you can think.

Justin Ford, interview with Crystal Windless, Memphis, TN, 7 December 2007.

MISS CLARA ANN TWIGG SEEN WITH OUT-OF-TOWN GUESTS—The popular group, all members of the "Younger Set" are seen at the lavish South Parkway home of Miss Clara Ann Twigg, young daughter of Mr. and Mrs. Lewis H. Twigg, Jr. . . . Seen in the living area are Miss Twigg who works with the record player on the floor as her dog looks on. . . Seated left to right are Miss Lois Hill, her New York City guest who is Miss Twigg's room mate at Palmer Institute where both girls are high school seniors; Lewis Harold Twigg, III, a senior at Morehouse and Miss Silvia Butler, a recent graduate of a Detroit high school and young daughter of Mr. W.W. Butler who was Miss Twigg's house guest for three weeks. Standing are Joe Terry of the Navy at Millington Cecile Washburn, a student at Kentucky State College and Gene Washburn, also a student at Morehouse. . . George Brown Jr. does not appear in the photo.

Memphis World, 25 August 1956, 2.
Photograph by Reese Studio.
2006.31.124

Clara Ann Twigg entertains a small gathering of friends on break from school. They are loosely arranged in a semicircle with Clara Ann at the center, propped against a record player as she selects a record to play. Her role as responsible hostess and accomplished young lady is confirmed by the gazes of her brother and their friends, who look in her direction. Although this is an informal event, the group's poise and sophistication are evident in their choice of dress. The canine companion reinforces this mood as he sits alert beside his owner.

The Twiggs were a well-known Memphis family. A successful businessman, Lewis H. Twigg Jr. became president of Union Protective Life Insurance Company in 1947. The family lived in a South Parkway home known for its beauty and finery. Due to segregation, African American homes were often sites for entertainment, providing privacy for small gatherings of friends, civic groups, and clubs. For certain functions, families called on photographers to document their events, which sometimes appeared in newspaper society columns.
RT

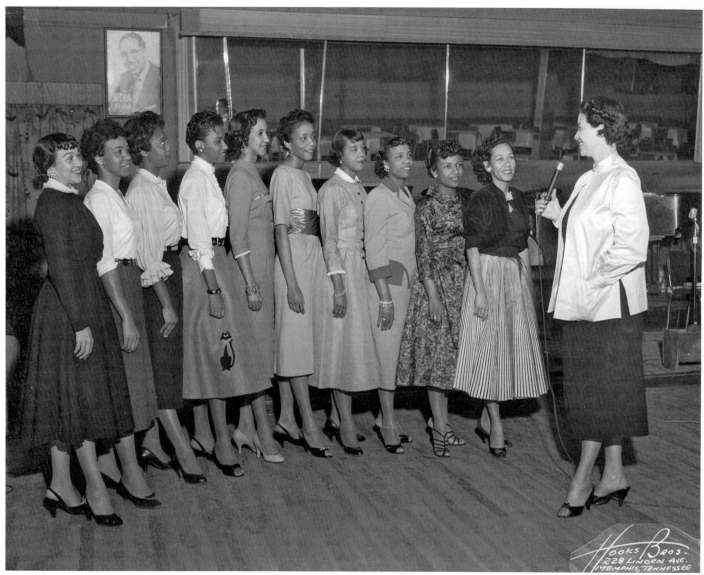

TEN OF THE MODELS TO BE PRESENTED IN A FASHION-BRUNCH SPONSORED BY THE SILHOUETTES, ALPHABETTES AND SIGMARETTES EASTER SATURDAY from 11 a.m. at Club Flamingo are seen above with their narrator and trainer, Mrs. Ethyl Venson who is seen at the extreme right. Seen left to right are Mrs. Gladys M. Greene, Miss Evelyn Bagsby, Mrs. Velma Johnson, Miss Elma Hubbard, Miss Mardine King, Miss Yvonne Exum, Miss Elsie Robinson, Miss Odell Boswell, Miss Geraldine Pope, and Mrs. Ernestine Martin.

Memphis World, 20 April 1957, 2.
Photograph by Hooks Brothers Photography.
2006.31.57

Also published: *Tri-State Defender*, 20 April 1957, 2.

For African Americans in Memphis in the 1950s and 1960s, fashion events involved more than just dresses and pumps; they represented a continuing struggle for equal treatment and opportunity. The ten beautiful models show us the sophisticated mode of the day. They paid attention to everything from the length of their skirts to the look of their earrings. The models are carefully staged, posing in a way to show off their outfits to the best advantage. Ethyl Venson looks comfortable with a microphone, probably due to her considerable time in the local limelight. Venson, a Memphis celebrity, cofounded the Memphis Cotton Makers' Jubilee and often organized local fashion and charity events. The portrait of a WDIA radio personality directly behind their practice session hints at the models' involvement in more areas than style.

The women's obvious grace added a chic note to a weekend of serious discussion and social activism. This photograph pictures wives and girlfriends of Kappa Alpha Psi, Phi Beta Sigma, and Alpha Phi Alpha fraternity members. These organizations sponsored Rev. Martin Luther King Jr.'s first visit to Memphis the night before the brunch. King, an alumnus member of the Morehouse College chapter of Alpha Phi Alpha, came at the behest of the three fraternities. Invited to address the group members and their guests, King's argument for nonviolent resistance to the oppression of African Americans resonated that Friday night.
EW

COMMUNITY VOICES

"We can't afford to slow up because our nation has a date with destiny and we've got to keep moving," [Dr. King] dramatically prophesized. . . .

His hour-long address, "A Real Progress in the Area of Race Relations," was delivered at the joint public meeting sponsored by Alpha Phi Alpha, Kappa Alpha Psi, and Phi Beta Sigma fraternities which were holding regional sessions here.

Another thing the Negro must do, Rev. King said, "is to continue to call upon the Federal government to use all its force and powers in behalf of justice. When we look up to Washington now it seems the judicial branch is carrying the load by itself."

He denounced the civil rights actions of the executive branch as "apathetic" and of the legislative branch as "evasive and hypocritical."

"We must let the powers that be know that we are determined to achieve freedom and in this generation," Rev. King said.

Moses J. Newson, "Leader Says We Must Keep Moving," *Tri-State Defender*, 27 April 1957, 1.

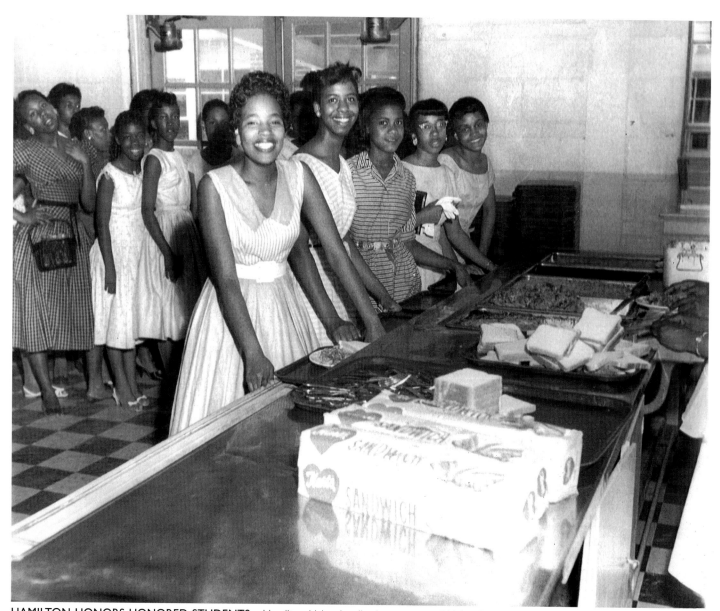

HAMILTON HONORS HONORED STUDENTS—Hamilton high school's elementary and high school departments cited Hamilton students who have brought honors to the school for their participation in all phases of school life in an honor program and banquet Friday in the school cafetorium.

Leading the students in the banquet receiving line was Bernice Hightower, Hamilton student council president.

Memphis World, 29 May 1957, 3.
Photograph by Tisby.
RS2006.2.14

The Green P. Hamilton elementary, middle, and high schools, among the oldest traditionally black schools in Memphis, were greatly respected educational institutions that grew from the two-room Greenwood School established by the Greenwood Colored Mission in 1866. After struggling for almost thirty years, the institution was taken over by the Shelby County Public School System in 1891, and in 1899 it opened as a Memphis City Public School. Due to overcrowding, it was rebuilt in 1941 and was designed to accommodate over 1,000 students. The school was originally named after the nearby Greenwood train station, but during its reconstruction the surrounding community wished to rename it after a prominent individual of color. Green Polonius Hamilton (1867-1932) was a highly regarded educator for nearly fifty years who taught at the Kortrecht and Booker T. Washington schools.

In this photograph, Bernice Hightower and four of her classmates lead the banquet line, facing the camera directly with bright smiles. Shot from behind the cafeteria counter, the photograph reveals two pairs of hands belonging to workers serving the girls. The *Memphis World* often reported events that commended young women for their propriety or beauty, and it is significant that these females were recognized for being accomplished students.
LC

COMMUNITY VOICES

Our philosophy is to equip our students with reliable information, pertinent to the problems of home, community and nation, to discover interests and aptitudes, striving for maximum development, mentally, morally and physically, carefully evaluating ideas, values and goals which will enable them to adjust in a changing economic and social order.

We also believe that our school should be friendly, united and cooperative and that our teachers should be aware of the needs of our children and then do something about them.

From the inside front and back covers of the Hamilton High School Yearbook, the *Hamiltonian*, 1958-1959.

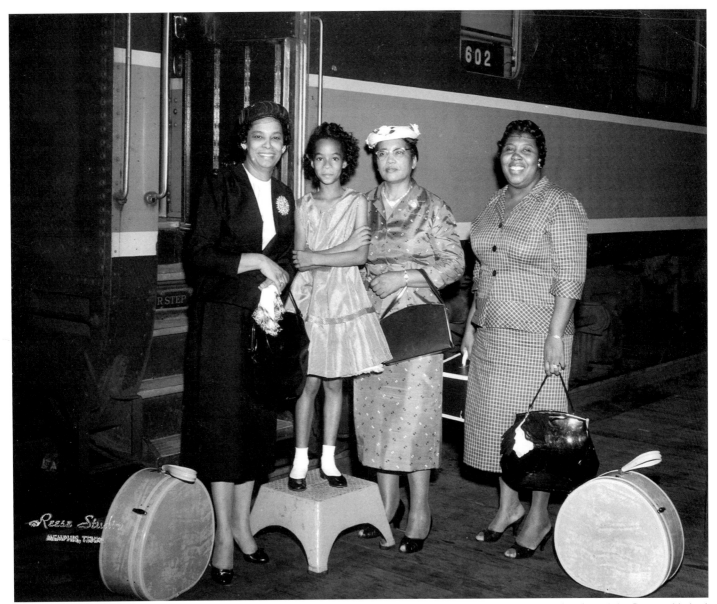

MRS. J.O. PATTERSON (left) her daughter, Janet Patterson, Mrs. Alice Dickens and Mrs. Mattie Wigley are seen as they board the Panama Limited to attend the wedding ceremony of Mr. J.O. Patterson, Jr., son of Bishop and Mrs. J.O. Patterson and Miss Marie Francine Anderson, the daughter of Dr. and Mrs. Leon Anderson. The event takes place in Wilmington, Del. this week. Bishop Patterson, who was in Los Angeles, flew to Wilmington to perform the ceremony.

Memphis World, 22 June 1957, 3.
Photograph by Reese Studios.
2006.31.73

Mrs. J.O. Patterson was the daughter of Church of God in Christ (COGIC) founder Bishop C.H. Mason, the wife of COGIC Bishop J.O. Patterson, and the mother of J.O. Patterson Jr.—the first black man to serve as mayor of Memphis when, for twenty days in 1982, he was chosen to hold the post vacated by the elected mayor until an election could be held—thus making her a member of one of the city's most prominent families. The details captured by the photograph speak to their prestige. Mrs. Patterson wears a crisp black suit with matching patent shoes and a stylish hat. She has a jeweled brooch pinned to the lapel of her jacket and clasps a white lace handkerchief in her left hand. Her daughter Janet is dressed appropriately in a youthful party dress matched with shiny black shoes. Mrs. Alice Dickens (a relation of the Pattersons) and Mrs. Mattie Wigley are equally coordinated in their patterned suits, fashionable hats, and pumps. The women are framed by two hatboxes, making the figural grouping the focal point of the photograph. Janet Patterson stands on a stool, placing her on the same level as the older, more mature women, signifying her importance within the group. The framing of Mrs. Patterson in the train's doorway highlights her as the intended center of the photograph—fitting for the matriarch of such an important family.

KD

COMMUNITY VOICES

That's Mattie Wigley [to the right], she was at one point the director of the large part of the music at the Church of God in Christ. . . . People came through on a regular basis, Billy Preston, Andre Crouch, a lot of those people came through. . . . They still do during the convention, [it] is called a Midnight Musical, and if you were a gospel artist of any caliber in the nation you were going to make sure you were going to make that.

Joseph Nelson interview with Marina Pacini, Memphis, TN, 18 April 2008.

WAITING FOR HIS RETURN are the mother and sister of Jesse Harvey Bradford. At the right is his mother, Mrs. Margaret Herron. On the left is his sister, Mrs. Fannie C. Walker, from whose home he disappeared.

Memphis World,
16 November 1957, 1.
Photograph by
Ernest C. Withers.
2006.31.50

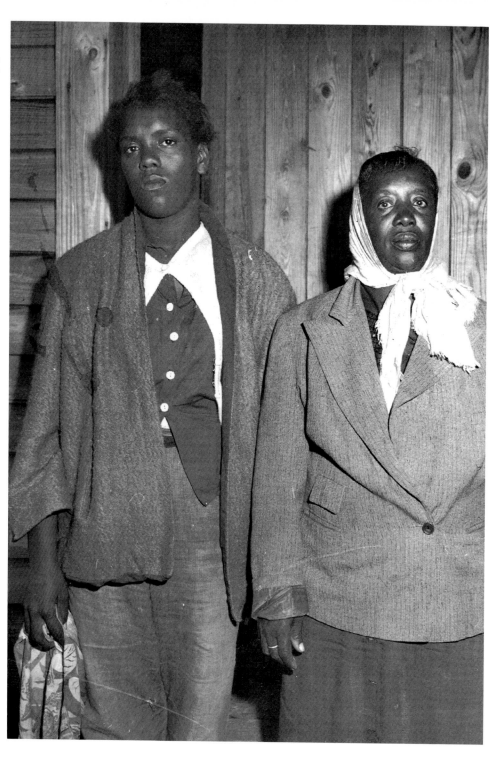

Two women humbly pose for a photograph that accompanied a story that was front-page news. They are dressed in workers' clothing, and their poses echo the well-known Farm Security Administration images taken during the Depression.

During the Jim Crow era, southern blacks lived under a reign of terror, as the nation was reminded by the murder of fourteen-year-old Emmett Till in 1955. When a child went missing, it was a community issue, as evidenced by the banner headline "MYSTERY SURROUNDS MISS. YOUTH'S ABSENCE" that appeared above this photograph. Jesse Bradford left the farm where his sister worked on Tuesday, 31 October, and did not return until 12 November, when he reappeared at the grocery store on Main Street around noon. He told police that he had been in Columbus, Mississippi. On further investigation, it was found that Bradford, who had a knack for coaxing rides from strangers, was picked up by Tol Herron, a white farmer from Pickens County, Alabama. Herron (no relation to Jesse's mother) told reporters that he had hired Bradford. After hearing the rumors of foul play, Herron gave Bradford a ride to Columbus and four dollars to take the bus back home to Pontotoc, relieving the family and community of great distress. KS

COMMUNITY VOICES

Jesse Bradford, 16-year-old cotton picker, walked into a grocery store and asked for a package of cigarettes shortly before noon Tuesday morning, thus giving the community of Pontotoc, Miss., a chance to breath again for the first time in almost two weeks. . . . The most persistent rumor is that he found a cache of whiskey and was kidnapped by bootleggers. . . . When the youth disappeared last Oct. 31, between two and three p.m., it was believed the same fate had befallen him that 14-year-old Emmett Till suffered in that cotton country a little more than two years ago.

Ernestine Cofield, "Mystery Still Hangs Over 11-Day Absence of Mississippi Boy, 16," *Tri-State Defender*, 23 November 1957, 10.

IT'S ALL OVER BUT THE DECISION: H.T. Lockard, second from right, chief counsel for the plaintiff, in the Memphis vs. O.Z. Evers bus segregation case, is seen leaving federal court Saturday morning after the state attorney general's office accepted "as final" the argument presented by attorneys representing the City of Memphis last Monday.

Lockard is flanked by, left – right, Attys. B.F. Jones, A.W. Willis, Jr. and R.B. Sugarmon, Jr.

A decision is expected within a month.

Memphis World, 15 January 1958, 1. Photograph by Ernest C. Withers. 2006.31.49

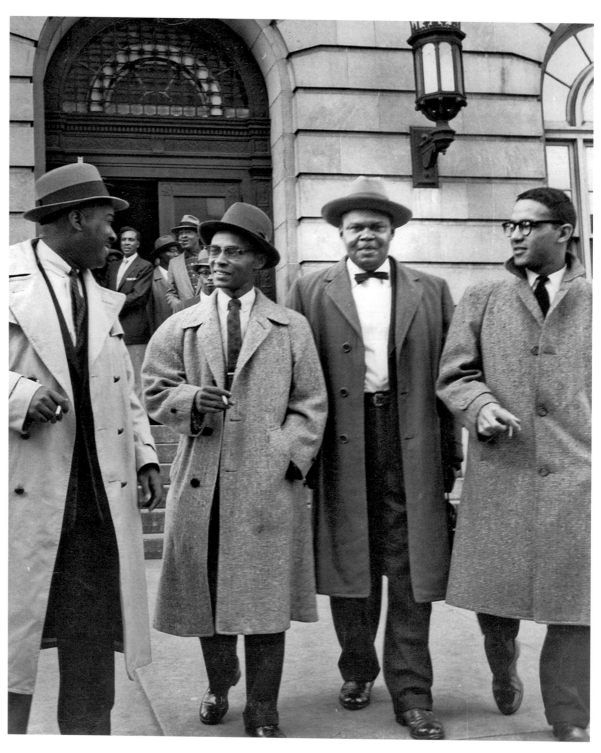

On 5 June 1956, a suit was filed in federal court by the NAACP on behalf of O.Z. Evers against the City of Memphis to end segregation on the Memphis Street Railway buses. The case moved slowly through the legal system and it was not until January 1958 that arguments were delivered and the court began to consider the briefs submitted. In June 1958, the Sixth Circuit Court dismissed Evers's suit, stating that as he was not a bus rider—he owned a car—he was not truly injured and therefore had no standing to sue.

Seven months later, the photograph that heralded the bus case as it finally began moving through the courts was considered by the editors of the *Memphis World* for publication on 15 August 1958, in conjunction with the suit filed by Jesse Turner in federal court to desegregate the Memphis Public Library system. Turner was denied use of the facilities several times during the summer of 1957. Even though in the end the photograph was not printed for the Turner story, the idea of reusing it was logical as the lawyers on both cases were the same and the issues under consideration were similar.

Five days after the Turner case was filed, Evers, president of the Binghampton Civic League, petitioned the city to desegregate all tax-supported facilities. He cited four years of waiting for city commissioners to address inequities and recent court decisions in urging them to immediate action. It was not until 12 September 1960 that the buses were integrated, followed by the library system on 14 October 1960, and the zoo, Brooks Memorial Art Gallery (today the Memphis Brooks Museum of Art), and many recreational facilities on 2 December 1960.
MP

COMMUNITY VOICES

The case went up on appeal because at that point there was one Federal District Court judge in the western district of Tennessee. He was called Speedy Boyd, but that was for cases other than civil rights cases, 'cause he buried them every time. . . . Evers had been around and known as a community organizer in Binghampton for some time prior to that. . . . The fact that he was a citizen, a registered voter here, and decides one day to ride the bus, they said that that takes away his standing as a party of interest with a right to sue. What happened, all of our cases, we never got a hearing on the first call, we had to appeal every one, which made us reluctant to go to the federal courts until John F. Kennedy became the president, and then the justice department changed its focus. Instead of fighting with the South, they joined hands with the civil rights movement.

Russell Sugarmon, interview with Marina Pacini, Memphis, TN, 14 March 2008.

O.Z. Evers and his friend Mr. Myers, both were postal employees and as good citizens I guess you would say, they were dissatisfied, disenchanted with the seating arrangements on the Memphis Street and Railway, as it was called. The two gentlemen came and discussed with me the notion of a lawsuit. Immediately I acquiesced and called Thurgood Marshall. He said make a rough draft and send it to me. I did so. And then he sent me the real deal, what to file. State law at that time required that any time you sued a municipality for a declaration of a city ordinance being unconstitutional, the governor had to be named. We named the governor. And also federal law required that the governor be notified of the date the suit was held. A three judge panel was convened. Judge Martin from the Court of Appeals, Judge Miller from Nashville and Judge Boyd from Memphis. We were ready to go for trial and some three or four weeks before the trial, a similar case was decided in the middle district of Alabama, and we cited that case as precedence for our action. . . .Thurgood sent Robert L. Carter to try the case.

H.T. Lockard, interview with Marina Pacini, Memphis, TN, 25 April 2008.

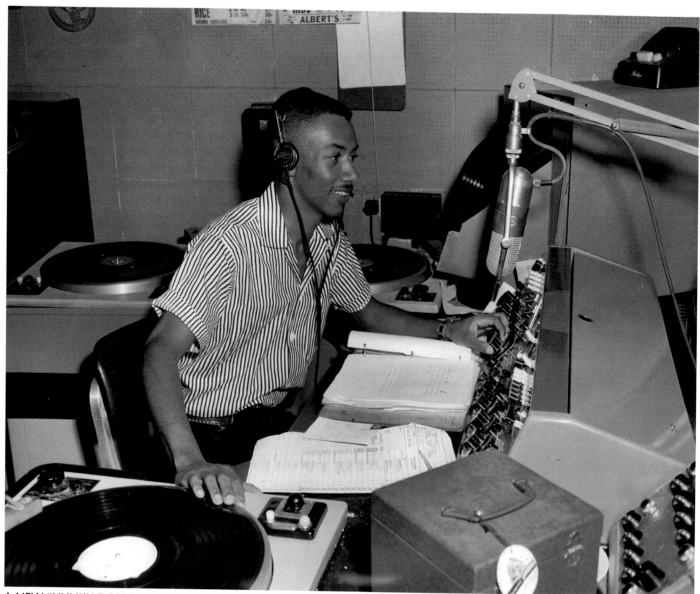

A NEW "HUNKY DORY"—Radio Station WLOK started offering Memphis a new "Hunky Dory" yesterday. He is Roland Porter, former WJAK, Jackson, Tenn., disc jockey who replaces Chester McDowell as the original "Hunky Dory." Porter, who is also a newscaster, was rated as the No.1 disc jockey during his stay in Jackson.

Memphis World, 30 July 1958, 8.
Photograph by E.H. Jaffe.
2006.31.97

Roland Porter is pictured at the control station as WLOK's new Hunky Dory. Although some distressed listeners felt he was usurping the former disc jockey's identity, Hunky Dory was a trademark of the station and not of any employee. Porter is captured on his first day of work. With one hand on a record and the other on the controls, he appears at ease in his work, his expression conveying his calm and cool attitude.

The Hunky Dory time slot on WLOK was associated with the style, flair, and rock 'n' roll attitude that appealed to a younger, hipper crowd in Memphis. The station had a symbiotic relationship with Stax Records and its Satellite Record Shop. WLOK was a place for new musicians to test a beat. Artists such as the Emotions and the Staple Singers were first heard on WLOK. This station was also known for the hip lingo of the disc jockeys, whose on-air patter harmonized with the smooth rhythm of the songs. In the documentary *The WLOK Story*, the Honorable D'Army Bailey quoted one of Hunky Dory's memorable lines: "There ain't nothing shakin' but the leaves on the trees and they wouldn't be shakin' if it wasn't for the cool breeze."
KS

COMMUNITY VOICES

He's one of the finest announcers and news reporter in the South. . . . He presents a "jive program" with quality—in that he has a college education and uses good English. Everybody will like him. He's a fine person.

Manager Eugene P. Weil quoted in "Memphis Has A New WLOK Hunky Dory," *Memphis World*, 30 July 1958, 8.

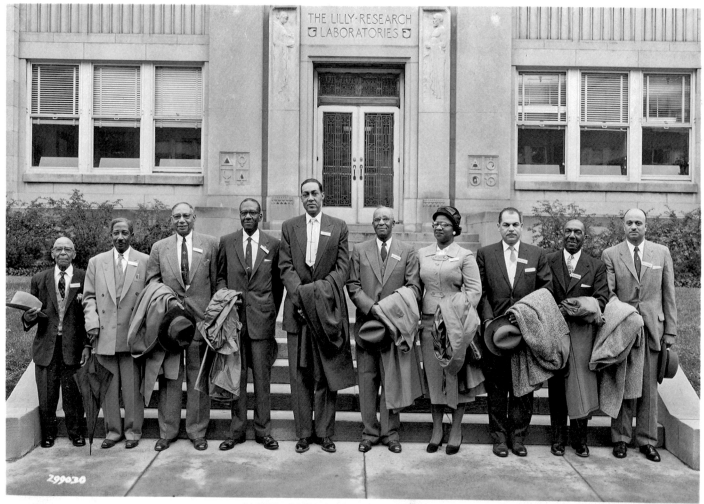

Guests of Eli Lilly and Company

BLUFF CITY MEDICAL SOCIETY
MEMPHIS, TENNESSEE

OCTOBER 26, 27, 28, AND 29, 1958

BASS PHOTO CO.

MEMPHIS DOCTORS AND MEMBERS OF THE BLUFF CITY MEDICAL SOCIETY are seen in front of Eli Lilly and Company in Indianapolis where they were given a trip with expenses paid last week. The Memphis physicians flew to Indianapolis where they were lavishly entertained by the company and by Indianapolis doctors. On their last evening in the Indiana city the group were guests at "Holiday on Ice."

Seen left to right are Dr. T.H. Watkins, Dr. L.A. Johnson, [Dr. W. Oscar Speight Sr.], Dr. W.A. Bisson, Dr. W.O. Speight, Jr., Dr. B.F. McCleave, Sr., Dr. Clara Brawner, Memphis's only Negro woman physician; Dr. Arthur E. Horne, Dr. N.M. Watson and Dr. Leland L. Atkins, president of the Bluff City Medical Society and vice chairman of the staff at Collins Chapel Hospital.

Memphis World, 8 November 1958, 2.
Photograph by Bass Photo Co.
2006.31.81

The most salient formal quality of the photograph is its near-perfect symmetrical organization. The door frames the four figures in the center, while the trio of windows on either side aligns with the three doctors on each end. They are positioned in a pyramid formation, with Oscar Speight Jr., from one of the most prominent African American families in Memphis at the time, in the center. The others stand on both sides of him, ordered in relatively descending height. This symmetry establishes them as a solid and stable society. Many have neatly draped their coats over their forearms and are respectfully holding their hats, allowing their faces to remain open to the community they serve. Dr. Brawner, the only black woman physician in Memphis, asserts her distinct feminine presence as she majestically shifts her body to her right.

Black-owned newspapers continuously challenged mainstream perceptions and provided comprehensive coverage of African American life, both the triumphs and the struggles. This image of the Bluff City Medical Society represents the fruits of black educational achievement.
AJ

COMMUNITY VOICES

The Bluff City Medical Society was organized somewhere in the early 1900's. Its membership was comprised of all licensed African American physicians who practiced in Memphis. They were not welcome in the white medical organization.

The group functioned much as a fraternity. They met monthly and discussed various facets of their medical practice, exchanged ideas and new information. They often invited speakers on topics relating to various medical areas, as well as representatives of pharmaceutical firms who informed them about their latest products. . . .

Much of their support comes from their wives, who are organized into The Ladies Medical Auxiliary. This organization is more social in nature than their husbands's. However, they have assisted the men in organizing public forums. With committees they work closely with their husbands to help with informing the public on important health issues.

Despite their preparation and level of expertise, Black doctors were not permitted to practice in the larger public or private hospitals until the late 60s and early 70s. At the earlier periods, if they had a case that required surgery or hospitalization, the patient was sent to the public John Gaston Hospital, where a white doctor, more often an intern, would attend to them, even new births. Most other births were held in the patient's home. Nevertheless, the Black doctors were resourceful and soon formed their own hospitals. . . .

Members of the Bluff City Medical Society were constantly honing their skills and knowledge by attending meetings throughout the country. In 1958, in recognition of their skill and dedication, members of the Bluff City Medical Society were invited by the Eli Lilly Pharmaceutical Company to attend an important seminar at their headquarters in Indianapolis, Ind. Ten members attended, flown there at the company's expense.

As the Civil Rights period advanced, members of the Bluff City Medical Society aggressively pursued their rights to practice in the larger arena of public and private hospitals of Memphis. Though the process of acceptance was gradual, full acceptance had become a reality by the onset of the 80s. Today there are innumerable Black physicians on staffs of public and private clinics and hospitals in Memphis . . . as a result of their efforts.

Emogene Watkins Wilson, faxed interview with Marina Pacini, Montgomery, TX, 11 December 2007.

"TEENAGER OF THE WEEK" is Lee E. Johnson, a 12th grade student at Hamilton High School. He is a member of the Math and Science Club and is also the winner of a four-year scholarship to Morehouse College. He is listed as one of the Top Ten of the scholar rating. Mr. Johnson resides at 1835 Rozelle and the son of Mr. and Mrs. M. Leve Johnson. He was first recommended by Mrs. Fred Waterford. His "Teenager of the Week" certificate will be presented by Willie Dunn, the director of this campaign.

Memphis World,
18 April 1959, 2.
Photograph by
Ernest C. Withers.
2006.31.51

Although some readers might be unfamiliar with "The Relationship of Parity to Anti-Matter," they would recognize the aptitude required of a student to master such a topic. The *Memphis World* regularly devoted space on the paper's second page to articles relating to the activities and accomplishments of local youth and schools. In addition to being listed in the paper's top ten scholar rating, Lee E. Johnson was also awarded a full scholarship to continue his education. The institution in Johnson's future was Morehouse, a historically black college for men, from which Martin Luther King Jr. graduated in 1948. During his senior year at Hamilton, Johnson was the president of the Math and Science Club and was involved in both the band and the orchestra. In the yearbook he stated that his ambition was to be a physicist and, along with Bertha Rogers, was voted Most Studious of his graduating class.

In suit and tie, Johnson is pictured facing his science project with ribbon in hand. The board notably takes up most of the image, and has been photographed to be readable, allowing viewers to consider its advanced subject. Johnson's placement by an award-winning project and the newspaper's recognition of his promising future are held up by the *Memphis World* as examples of pride and emulation for its readership.

LC

'He Lived A Good Life,' Said Minister
At Rites For L. Charles Sharpe

Memphis World,
20 June 1959, 2.
RS2006.2.40

Also published:
Memphis World,
25 January 1955, 1;
Memphis World,
6 May 1955, 4;
Memphis World,
17 February 1956, 4.

One of seventeen children, Lucky C. Sharpe, whose name was sometimes printed as Luckie C. Sharp, was born in Beaumont, Texas, in 1900. A star athlete in college at Prairie View A&M and one-time professional baseball player, he made his name locally as an educator. From 1929 to 1951 he was principal of the Douglass School in northeastern Memphis. During the Depression he established the Live at Home Project, a gardening and canning initiative that provided food for students and resident families. Revenue generated from sales helped many stave off foreclosure. By 1936 there were some 1,100 such gardens in the neighborhood. When she visited Memphis in November 1937, First Lady Eleanor Roosevelt went to Douglass to meet the individuals responsible for the nationally acclaimed community project. In 1946 Sharpe opened Douglass High School, and shortly before his retirement oversaw its move into a brand-new thirty-two-room facility at the corner of Ash and Mount Olive. Through most of the 1950s he worked for Universal Life Insurance Company, joining Mammoth Life Insurance a few months before his death in 1959.

This undated photograph finds him dressed in a houndstooth jacket and patterned tie with starched white shirt and silk handkerchief. A calm demeanor and benevolent smile mark him as one of Memphis's guiding fathers. Fittingly, a man noted for his civic engagement and multiple accomplishments is depicted in a half-length portrait that harks back to Renaissance convention, derived from Roman precedent, for depicting men of achievement. As his neighbors knew well, Sharpe's fame resulted from his selfless work for his community.
DMcC

COMMUNITY VOICES

When one speaks of the Douglass Community, one immediately thinks of Prof. Lucky Sharpe, Principal of Douglass School since 1929. He is the one man known to every resident of the community and there is not a family in the subdivision which doesn't boast of a Douglass graduate.

But Prof. Sharpe's popularity as a leader in Douglass does not come merely because he is Principal of the school. It comes because he saw years ago the possibilities of making Douglass the "Garden Spot" of Memphis, and has worked untiringly through the years to make it modern and progressive in every sense. . . .

The vision, foresight and leadership exemplified by Prof. Sharpe has proven time and again a boom and life saver from the people in Douglass who come to him with all types of problems. To them he is, at times, teacher, lawyer, doctor, priest and preacher—people in Douglass have trusted him with the care of their children and their own destiny, and he has never let them down.

No, the story of Douglass could never be told without talking about Principal Lucky Sharpe.

"A Dream Coming True for Principal Lucky C. Sharpe," Memphis World, 11 April 1950, 1.

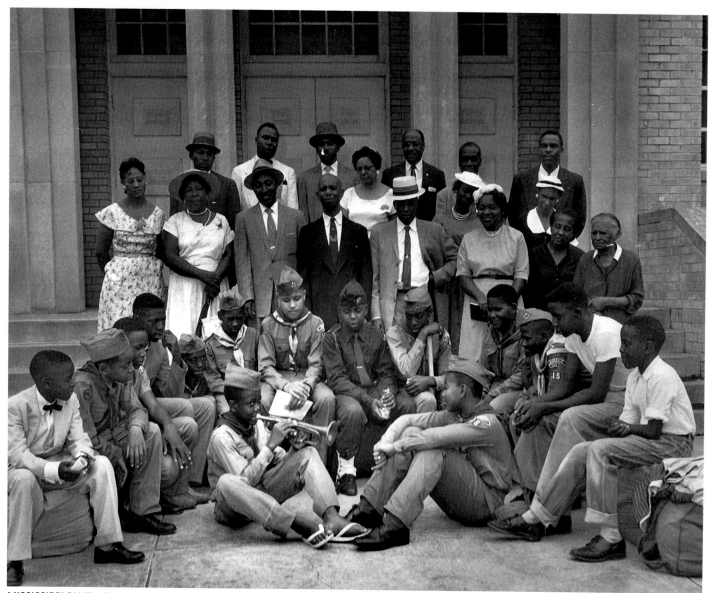

MISSISSIPPI BLVD. CHRISTIAN CHURCH TROOP NO. 15, Boy Scouts of America, Inc., spent a one-week camping trip at Fuller Park. Last year as well as this year, the troop was the largest single group to go camping. In the background are the Mother's Club women who organized the fund raising campaign to help defray the camping expense; and some of the men of the church who furnished transportation to and from the camping site.

The adults are, first row, left to right: Mrs. Willie Mae Lynn, Mrs. Marie Adams, Henry L. Jackson, Charles Chatman, scoutmaster; Dempsey Gates, Mrs. Violette Beckwith, and Mrs. Charles Green. Back row: Abe Thompson, George Parker, William Hughes, Mrs. Albert S. Bennett, president of the Mother's Club; J.T. Chandler, institution representative; Mrs. Josie Robinson, Mrs. Morris James, Paul Spearman and Will B. Hurt.

Memphis World, 1 August 1959, 2.
2006.31.78

Founded in 1921, the Mississippi Boulevard Christian Church was the first African American subsidiary of the brotherhood of Christian Churches in Memphis. Since its inception, the church has become one of the largest congregations in Memphis with approximately 2,000 members and seventy outreach ministries, including scouting. Denominational chapters of the Boy Scouts have a long tradition of aiding young men in making sound ethical and moral choices as they develop and grow.

The contrast in body language between the adults and the boys suggests the generational distance separating the groups. The parallel lines of the pillars and the church doors echo the linearity of the adults' bodies as they stand facing the photographer. Juxtaposed against their solidarity are the boys, many of them slouched over as they stare at each other, at the trumpet player, at the ground—all except one seemingly unaware of being captured on film. Connecting the two portions of the image is the gaze of the adults, pride evident in their expressions. This photograph was taken on the steps of the former church building that stood from 1952 until 1984, reiterating the congregation's commitment to instilling the Boy Scouts' teachings through the auspices of religion.
CC

COMMUNITY VOICES

My family and I think that I am the first person on the left, seated in the first row of the picture. . . . I do recall the trip to T.O. Fuller Park. It was my first camping trip and the first time I was ever in a swimming pool. We were all given swimming lessons and most of the scouts did learn to swim.

While I do not recall the names, places and events of 1959, reviewing the picture reaffirmed that I had excellent, caring parents. Neither had more than grade school education but they wanted their children to get a good education and be more successful than they ever were. My mother made me get involved in scouting, take piano lessons, stay active in church, study hard and respect others. I didn't understand nor appreciate the sacrifices they were making at the time, but it worked.

I was their first born to graduate from college. . . . I retired two years ago at age fifty-seven from the Social Security Administration in Baltimore where I was the Associate Commissioner for Central Operations. . . . I had a very successful thirty-five-year career. There's no doubt that my childhood experiences, including scouting helped me to stay focused and navigate the difficult challenges of my day.

Burnell Hurt, e-mail correspondence with Christina Cooke, Baltimore, MD, 19 September 2007.

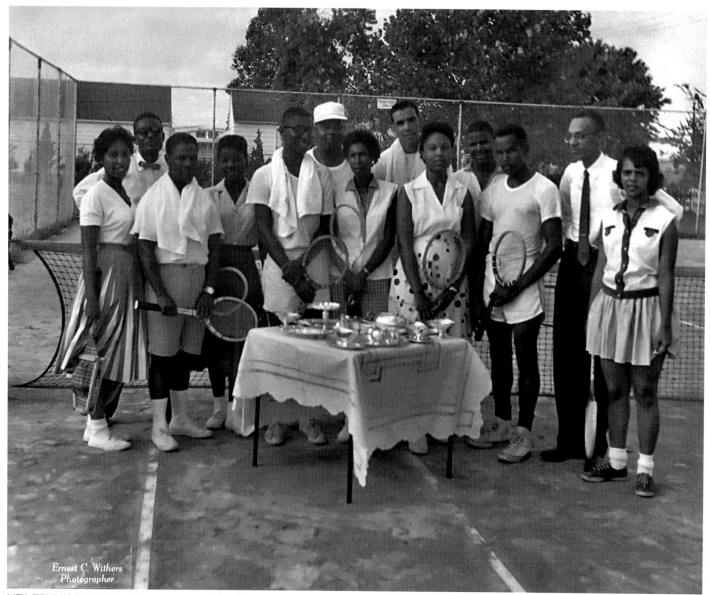

MTA TENNIS PLAYERS—Here are some of the players who participated in the recent Memphis Tennis Association Tournament. Front row, left to right: Mrs. Freddie Green, MPC champion in women's singles; William Cox, Grant School principal, men's singles champion in Division II of MPC Tournament; Mrs. Clance Sykes; Alphonso Smith; Mrs. Agnes P. Yette; Mrs. Rose Marie Long; Alphonso Yates, Division I doubles champion; Mrs. Betty Cash.

Second row, left to right: Napaleon Williams, MTA treasurer; William Knight, second place winner in men's doubles in MTA and MPC tourneys; Benjamin Blakey; Joseph Trotter, MTA publicity director, and Dr. John E. Jordan, second place winner in Division II of MPC tourney, president and founder of MTA.

Memphis World, 5 September 1959, 7.
Photograph by Ernest C. Withers.
RS2006.2.33

In 1952, Dr. John E. Jordan established a local chapter of the U. S. Tennis Association in order to further the development of tennis in the Memphis area and to educate its players on proper sportsmanship. The members consisted of African Americans ranging from students to school principals. They played individuals who were students and professors from schools such as Tennessee A&I State University and Meharry Medical College, as well as doctors from cities such as Nashville. The successful careers of the MTA players and their opponents suggest that these individuals pursued tennis as a leisurely activity aimed at social interaction rather than as an occupation for monetary gain.

During the 19th century, serving tea during a tennis match was an activity reserved for the aristocracy, and thus became a hallmark of social prestige. The focal point of the photograph is the silver, highlighted by a white tablecloth and surrounded by the players. Its presence forges a connection between the MTA and this patrician ideal.
CC

**Miss Kathryn Frazier Passed Friday
Morning; Rites Held Wednesday**

Memphis World,
30 April 1960, 7.
RS2006.2.93

In 1899, Manassas opened as a county elementary school. It quickly outgrew its original two rooms, a pattern of growth that continued well into the 1960s. Teachers, a library, and a librarian were added between 1917 and the mid-1920s through funding from the Rosenwald Foundation established by Julius Rosenwald, a Sears, Roebuck & Co. executive. Manassas was the first accredited high school for African Americans in Shelby County, graduating its initial class in 1924; Booker T. Washington High School began graduating city students in 1928. Louis Hobson, appointed principal in 1953, believed that all students could achieve greatness; he steered the school through accreditation by the Southern Association of Colleges and Secondary Schools.

Equally important to student success were the teachers such as Miss Kathryn Frazier, who spent most of her life in Memphis, attended Mississippi Industrial College at Holly Springs, and taught at Manassas for thirty-eight years. The photograph accompanying her obituary presents an intelligent, thoughtful woman. Her hair is swept up in a professional style; she wears glasses and pearl earrings. The apparent severity of the image—no background, the tight focus on Miss Frazier—is offset by her pose. Rather than sitting fully frontal and gazing at the viewer, her shoulders angle diagonally back into space, her head is tilted, eyes looking off to her right, with a warm expression. The white collar encircles her face, drawing attention to what can only be described as a lively, engaged presence. She must have been formidable in the classroom.
MP

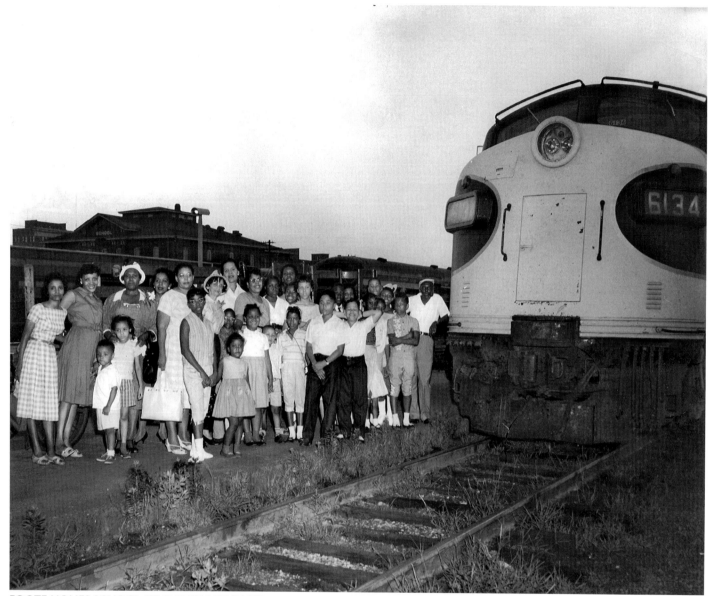

FOOTE HOMES SCHOOL STUDENTS RETURNED recently from an educational tour to Washington, D.C. Nineteen students, accompanied by five adults, made the trip. Here they are shown with relatives and friends as they stepped off a Southern railroad Company coach. Mrs. Calverta Ishmael, tour director and head of the school, said next year the school is planning to sponsor a trip to New York City. The first two trips were to Chattanooga, a year ago, and Collierville, two years ago.

Memphis World, 2 July 1960, 1.
2006.31.6

The Foote Homes were built in 1941 to improve the standard of living for African Americans. At the time, the homes were the South's largest housing units of their kind. William E. Foote developed this community with the intention of creating a place where families could grow and improve. Twenty years later, the project remained just as vital.

Framed by the roofs of the buildings in the background and the tracks in the foreground, a group of children and their parents stand next to the train. They have just returned from Washington, D.C., where they visited more than twenty historic sites. This rare opportunity made for a memorable journey that united generations within the Foote Homes community.
KS

COMMUNITY VOICES

Mrs. Calverta Ishmael, teacher at the Foote Homes Kindergarten, took a group of her small kiddies east to Washington, D.C. for an educational tour. The group went up to the Nation's capital on the Tennesseean and were guests at the new Dunbar Hotel. . . .

In Washington the tours were made in an Atwood Bus . . . and their efficient guide was Mrs. Edna Brewer. Among the twenty or more tours made were the Treasury Department, the Lincoln-Jefferson Memorial, a tour of the city, Tomb of Unknown Soldiers, Lee's Mansion, Pentagon Building, Mount Vernon, Washington Monument, the Nation's capital, the White House, the Supreme Court Building, and the Congressional Library. The group spent 15 minutes in the House of Representatives which was in session.

Jewel Gentry, "Foote Homes' Kindergarten Kids Make Educational Tour Of Washington, D.C.," *Memphis World*, 2 July 1960, 3.

Mrs. Ishmael was the head of the school, I was in her kindergarten, which was held in the lower part of the Foote Homes auditorium. . . . She may have just pulled some kids together who were in the Foote Homes to go on the trip. She was a very, very strong community person. Her school was a foundation for a lot of kids getting just a real good start in things. She was one of those stand outs in the community who was just one of those rocks, those anchors that a lot of people had in the community. She helped a lot of people; she also lived in Foote Homes.

Most of the people in that neighborhood went from Foote Homes kindergarten to what was then Porter Elementary and Junior High and then Booker T. Washington High School, and a lot of people to LeMoyne College. So you could get all your education right there in that maybe 5 mile radius.

Joseph Nelson, interview with Marina Pacini, Memphis, TN, 18 April 2008.

SUCCUMBS—Mr. John Henry Robinson, Sr., a veteran of 50 years with the Illinois Central Railroad, passed Wednesday, October 26 in a Chicago hospital.

In 1957, Mr. Robinson received a "golden pass" representing faithful, meritorious service to his job.

He leaves his wife, Mrs. Marie Robinson, his children: Miss Verl Robinson, John Robinson, Jr. and Atty. and Mrs. B. F. Jones of Memphis; Mr. and Mrs. Cleaster Lewis and son, Ronald of Detroit, Mich.

Mr. Robinson was a faithful member of St. Andrews AME Church. Services were held Nov. 2 at 8:00 p.m. from the Southern Funeral Home. Elder Blair T. Hunt and Dr. H.H. Jones officiated.

Memphis World,
9 November 1960, 3.
RS2006.2.41

The "golden pass" that the Illinois Central Railroad (ICR) presented to John Henry Robinson for fifty years of service was good for a lifetime of travel to any stop on its line. Robinson's career with ICR paralleled a strong relationship between the railroad and Memphis. Having come to the city in 1896, ICR was by 1955 the municipality's second-biggest employer, and local industries comprised the second-largest market for the company. Its business had expanded with the metropolis. Some 3,500 Memphians worked as ticket salesmen, baggage porters, and switch tenders at Central Station, and as loaders for mail cars and cotton cars.

In the photograph Robinson stands in front of a house, presumably his home. He is dressed as a successful workingman in a suit with a vest, a tie, and a handkerchief in his breast pocket. His face weathered with age, he gazes directly at the viewer. The vertical door frame, window, and stairs echo his upright posture. Though the newspaper cropped the image at waist level, the published version still conveyed his dignity. As there was no obituary section of the *Memphis World* at this time, the story of Mr. Robinson ran with society news of prominent members of the community.
MM

OWEN CORONATION— Coronation of Owen College Queen Betty Jean Johnson by the decree of the students of the college was performed on the 5th of January in the Owen Chapel. Pictured (left to right) Miss Johnson is shown receiving flowers from Miss Dorothy Bradford representing the Student Council.

Memphis World, 14 January 1961, 1. Photograph by Ernest C. Withers. RS2006.2.92

The Tennessee Baptist Missionary and Educational Convention founded Owen College in 1954 as a black junior college dedicated to providing religious and basic academic instruction. The college served students until 1968—years coinciding with pivotal events in the civil rights movement, particularly *Brown v. Board of Education* (1954) and the integration of the University of Mississippi (1962). Betty Jean Johnson attended the college when Owen students launched the Memphis student sit-in movement in March 1960. She was a sophomore education major when she was crowned Miss Owen 1961 by popular vote. Here she smiles for the camera after being crowned. Shot from below, she and her classmates loom large before the camera, enhancing Miss Johnson's position as college queen. After Owen merged with LeMoyne College in 1968, the titles were changed to Mr. and Miss LeMoyne-Owen College, where the tradition continues to this day.
RT

COMMUNITY VOICES

The coronation of Owen College's queen was held Jan. 5 at the college. Miss Betty Jean Johnson, a very charming and most lovely young lady was firmly the choice of Owenites on this sparkling occasion as they voiced their approval.

"Crown Owen Queen," *Tri-State Defender,* 14 January 1961, 4.

OWEN ART SHOW—At the recent art show at Owen College presented by the college library, a group of interested students posed with the two participating artists, Longino A. Cooke, Jr. (center), and Owen student-artist Louis Hampton, Jr. (sixth from the left). Left to right: Delores Prince, Otha Mabry, Mary Ann Duck, Willie Spence, Mr. Cooke, Mr. Hampton, Betty Jean Johnson (Miss. Owen), Marva Sholders, and Mary Richardson. In the background are examples of Mr. Cooke's artwork.

The interesting show displayed the talents of the two young artists through water paintings, ink drawings, spatter abstracts, wood carvings, wood sculpture, charcoal and oil paintings, showcards and commercial illustrations.

Memphis World, 4 February 1961, 2.
Photograph by Ernest C. Withers.
2006.31.29

In 1947 the Tennessee Baptist Missionary and Educational Convention began planning Owen Junior College. The school, located on property at Vance Avenue and Orleans Street, was named after its founder, Rev. Samuel A. Owen, pastor of Metropolitan Baptist Church. Upon its opening in 1954, Owen was, according to its president, "the only Negro college bought and paid for entirely by Negroes" and the only black junior college in Memphis at the time. Three years later it became Owen College. It merged with LeMoyne College in 1968 to become LeMoyne-Owen College. The Owen curriculum included general education courses as well as more specific instruction leading to associate degrees in art, applied science, or religious education.

This group poses at an art exhibition mounted in the library. The art on display was conceived in the dominant mid-20th-century styles of art, abstraction and naturalism. The students were among the small, yet growing, number of some 233,000 African Americans attending college nationwide in 1961.
MM

COMMUNITY VOICES

We [Walter Guy, dean of high school art teachers and Manassas High School teacher, and I] became fast friends. I think Walter's either wife or one of his daughters was secretary at Owen Junior College and he asked me if I would do an exhibition. They wanted him to do it and he said that he was just loaded down. And he said furthermore I want to get some of your work out there, so he asked me if I would do it. And I okayed it. . . S.A. Owen was a young junior college at that time, and they didn't have as historic a background as LeMoyne. Now I know LeMoyne did [have other art exhibitions before this], but to my knowledge this was the first exhibition that Owen had done. . .

Longino Cooke, interview with Marina Pacini, Memphis, TN, 23 October 2007.

EMPTY SHELVES—Is the boycott still on? When this Negro-owned grocery store in Brownsville, Tenn., failed because salesmen stopped servicing it with food supplies, several colored citizens in Brownsville and Haywood County set up a co-op and took over operation of the store. But, they, too, have been unable to purchase necessary supplies. They may find it necessary to truck supplies from Memphis. The boycott began when Negroes exercised their right to register and vote.

Memphis World, 18 February 1961, 1.
2006.31.1

In 1958, African American residents of Haywood and Fayette Counties (almost two-thirds of the population of the former and about three-quarters of the latter) began a voter registration drive. Although the white population was in the distinct minority, they had dominated at the ballot box as most blacks were disenfranchised. By the end of the year, reprisals and intimidation tactics began, with measures becoming more punishing over time. Sharecroppers and tenants were evicted from their farms and homes. People lost their jobs and were denied medical care, as well as service at white-owned gas stations, grocery stores, and clothing stores. Despite the harsh treatment, citizens continued to line up at the courthouse to register. Even those registered were turned away from the August 1959 primary. In response, Attorney James F. Estes filed complaints with the federal Civil Rights Commission and filed suit against the local Democratic Party. Residents founded the Fayette County Civic and Welfare League to provide food, clothing, and fuel, and, most importantly, to help find homes for the displaced families. Those who had no place else to go were housed in tents on land owned by Shepard Towles, a black farmer. Tent City, as it came to be known, received national attention from the press and support from the federal government, churches, civil rights organizations, and aid agencies.

Cutting off supplies was one of the methods employed to drive potential voters from Fayette County. As witnessed by this photograph, what shoppers often found at black-owned stores was nothing to buy. The light reflecting off the vacant surfaces and the dramatic diagonal highlight the empty shelves, which stretch across the center of the image. The push broom on the bottom shelf, the cardboard boxes, and the few other random items underscore that this store was not open for business. It was through the efforts of many people and organizations, locally and nationally, that citizens were able to continue their efforts to vote in the county.
MP

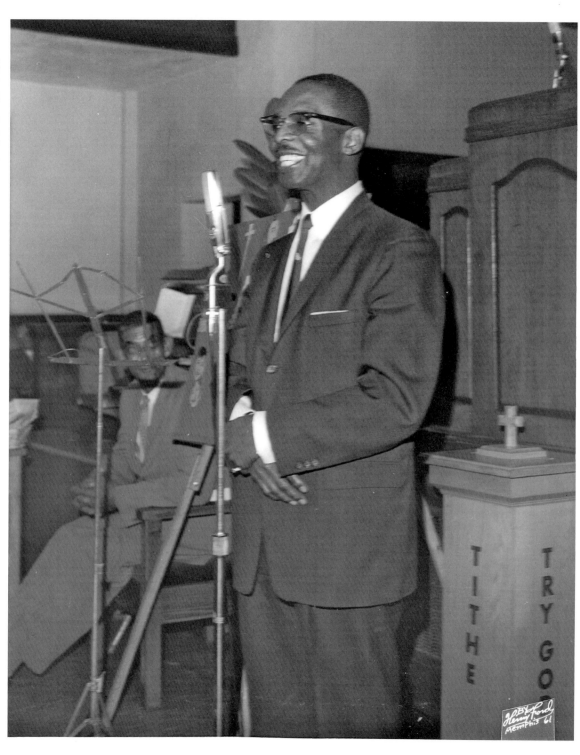

REV. W.C. HOLMES,
from **OVER 800 ATTEND BAPTIST INSTITUTE**

Memphis World,
25 November 1961, 1.
Photograph by
Henry Ford.
RS2006.2.31

Rev. Wesley Clyde Holmes (1916-2001) taught a class at the 24th Annual Baptist Training Union Congress held in November 1961. This congress, which furthered ecclesiastical education and leadership, was directed by the Tennessee Baptist Missionary and Educational Convention (TBMEC). The convention initially owned and later became the primary benefactor of Owen College; for this reason, the annual training congress was held partially at the campus.

Beginning in 1955, Rev. Holmes commenced his forty-four year pastorship of Beulah Baptist Church on Douglass Avenue. He was a board member of Owen, and later served as president of the TBMEC. Here he stands comfortably before an assembly, captured between a microphone and a pulpit. These vertical elements constitute the photograph's linear composition and parallel his upright posture, which exudes confidence and strength. He wears a business suit for the occasion. The contrasts between his shirt, coat, and tie direct attention to his face, which communicates interest and enthusiasm.
RT

COMMUNITY VOICES

The Memphis Sunday School and Baptist Training Union Congress registered 851 persons in the 24th Annual Institute just closed, according to Charles H. Ryans, Congress president.

Seventy-one churches participated in the institute, which was held at the St. John Baptist Church and Owen College.

Forty-four courses were offered covering all phases of leadership in church work, under the direction of Reverend A. M. Williams, dean of the Congress. . . .

Rev. W. C. Holmes was the instructor in course 124B, Jesus and His Teachings, which class reported the largest amount.

From "Over 800 Attend Baptist Institute," *Memphis World*, 25 November 1961, 1.

Reverend Holmes was known for his winning smile and humor. This smile and humor, however, did not mask his ability to be steadfast and unmovable in his beliefs. He loved God and shared that love with all he came in contact with.

From the funeral program obituary of Reverend W.C. Holmes, March 2001, provided by M.J. Edwards of M.J. Edwards & Sons Funeral Homes.

CLOSING BIG DEAL—George W. Lee, left, manager-director of the Memphis District of Atlanta Life Insurance Co., and Jesse Turner, executive vice president of Tri-State Bank, close the deal that resulted in the insurance company selling the bank a $54,000 group policy for its officers and employees.

Memphis World, 2 June 1962, 1.
Photograph by Mark Stansbury.
2006.31.69

Pictured are George W. Lee and Jesse H. Turner, two of Memphis's most prominent black businessmen and civil rights strategists. Lee, an army lieutenant during World War I, a wealthy insurance executive, and a leading figure in Memphis's Republican Party, was a living embodiment of elevation and success. Turner, too, built an impressive list of achievements. A graduate of LeMoyne College, a World War II veteran, the city's first black CPA, the president of the local chapter of the NAACP during the 1960s, and the first black chairman of the Shelby County Board of Commissioners, he fulfilled his self-imposed mission: to fight for justice and equality for all. While at Tri-State Bank, he represented minority banks in the largely white American Bankers Association.

In this photograph, the stark white document linking the two men suggests their business collaboration. Lee, dressed in a three-piece suit, is slightly more formally attired than Turner, but both appear quite professional. Structural elements of the room, such as the streamlined wooden panel behind the men's heads and an almost completely bare desk, highlight the organized, strict simplicity of this executive's office. What emerges is a vision of black productivity, outside of the stereotypical field or factory context, with Lee and Turner working in a space that a person of color owns. Ultimately, the image displays the potential of black businesses to succeed.
AJ

QUEEN OF CITY POOLS
—Sixteen-year-old Flora Fleming, daughter of Mr. and Mrs. James Fleming, 2105 Hubert, and a senior at Douglass High School, was crowned "Miss City Pool" last week. More than 40 competed for the title. Alternates were Janet Braswell, 15, of 1524 Gold (first) and Mary Wade, 15, of 2524 Hunter (second).

Memphis World,
25 August 1962, 1.
2006.31.5

On the night of August 16, 1962, the five public pools open to black Memphians hosted a communitywide water show and Miss City Pool contest at L.E. Brown pool on Georgia Avenue. Youth from Tom Lee, L.E. Brown, Gooch, Washington, and Orange Mound city pools participated in the show, which included such events as formation swimming, stroke demonstrations, and a choreographed water ballet. The main event was the Miss City Pool bathing beauty contest, in which nearly fifty teenage girls competed. This was the last year the community water show took place. Following a Supreme Court order in 1963, the Memphis City Commission and Park Commission ordered that all public recreational facilities be desegregated, but closed all ten public swimming pools for two years because of alleged financial losses—a statement greatly criticized by Memphis citizens and the NAACP. Two years later on 15 June 1965, six of the newly integrated public pools were finally reopened to the public.

In this photograph sixteen-year-old Flora Fleming, Miss City Pool of 1962, steps out from a gilded frame, pretty as a picture. She is partially concealed by the curtain, and although shown only in a bathing suit and high heels, she is modestly covered by a sash, trophy, and bouquet of carnations. For Fleming and others who participated in the water show, this event allowed them to showcase their talent as representatives from their own pool and neighborhood.
LC

COMMUNITY VOICES

You had city pools for whites and city pools for blacks. . . . There was a big pool there that we used to go to called Washington City Pool in Washington Park. It was off of North Second Street or somewhere like that. . . . We would ride the streetcar from McLemore all the way across town. And that was quite an event to go swimming. . . .

Alma Roulhac Booth, interview with Marina Pacini, Wyncote, PA, 11 October 2007.

MRS. MEREDITH RETURNS TO JACKSON—Mrs. James Meredith at the Memphis Municipal Airport Sunday afternoon before boarding a Delta flight to Jackson, Miss. where she is a student at Jackson State College. She spent the weekend here with her husband who came up from "Ole Miss."

Memphis World, 13 October 1962, 1.
Photograph by Mark Stansbury.
2006.31.2

Less than two weeks after James Meredith integrated the University of Mississippi on 1 October 1962, a *Memphis World* headline declared: "Meredith Gets Haircut During Weekend Visit Here With Wife!" His visit betrayed no hint of the chaos at the university, where 1,400 federal troops and marshals using tear gas and bayonets were required to ensure his enrollment. Further trauma ensued as countless rioters were arrested and injured; two people were killed. As evidenced by the headline, the enormity of the civil rights victory brought Meredith's private life into the spotlight.

In this candid photograph that contrasts sharply with the national media attention focused on Ole Miss, local reporter McCann Reid interviews June Meredith. When reproduced in the *Memphis World*, the picture was cropped to focus solely on Mrs. Meredith. In the original image, however, their informal interaction is the focal point. They are framed by a plane's wing above them and a roof in the distance. Although a public image of Mrs. Meredith, the photograph clearly shows her close proximity to Reid, as well as to the camera, making this a more intimate portrayal of a life subjected to public scrutiny.
RT

COMMUNITY VOICES

On the other hand, this is nothing new to my wife. We spent most of our courtship discussing my plan to come back to Mississippi some day, and I guess you could say her understanding that I would try to do this sometime was almost part of the marriage contract. She has been truly marvelous through all of it. I called her three nights after I entered the University, and she picked up the phone and was so calm you would have thought we had just finished a game of 500 rummy and she had won. She is a remarkable woman.

James Meredith, *Three Years in Mississippi* (Bloomington: Indiana University Press, 1966), 227.

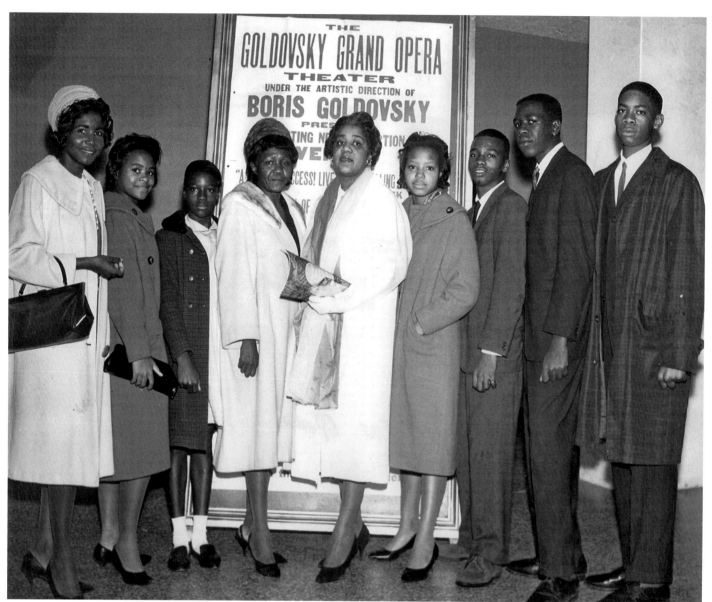

AN EVENING AT THE OPERA—The Memphis chapter of Links, Inc., is providing a cultural enrichment program for young people residing at Goodwill Homes, 4590 Goodwill Road. This is being done through a special Links committee, of which Mrs. Alma R. Booth is chairman. On Nov. 17, the Links provided opera tickets and Mrs. Booth escorted seven Goodwill Homes youngsters to the Auditorium to hear and see "La Traviata" which was presented by Goldovsky Grand Opera Theater. Left to right: Emma Barrett, Cleaster Adams, Eva Rivers, Mrs. Mildred Heard, director of the home; Mrs. Booth, Juanita Adams, Narazine Moore, Willie Dickson and Arthur Davis.

Memphis World, 1 December 1962, 1.
Photograph by Ernest C. Withers.
2006.31.27

Also published: *Tri-State Defender*, 8 December 1962, 9.

Founded in Philadelphia in 1946, the social organization Links, Inc. aimed to respond to the needs and aspirations of black women. One of their goals was to implement programs that would foster cultural appreciation through the arts. In this photograph, Alma Booth, the chairwoman of Links's cultural enrichment program in Memphis, escorts a small group of youths from the Goodwill Homes to the opera. Founded in 1957, the agency was a haven for underprivileged black children whose family situation was unstable. The ultimate goal was to rehabilitate the children's domestic situation. If this goal could not be achieved, however, the children would stay at the Goodwill Homes through high school graduation. Then the administration would help with either college admission or finding a job.

Formally dressed for the occasion, the group is organized by height, with the two adults in the middle. Something not discernible from the photograph and its caption, but vitally important to understanding the picture, is the fact that Ellis Auditorium had only been desegregated for five months. Where Mrs. Booth and her guests once would have been forced to climb to the uppermost balcony to enjoy the performance, they were now free to sit where they pleased. In a period of intense, though lessening, segregation and limited cultural opportunities, the Links were able to provide a unique and enlightening experience to a handful of young Memphians.
KD

COMMUNITY VOICES

The Links is a women's organization started in Philadelphia. . . . It now has chapters in practically all cities of the country as well as Africa and Germany. . . . The organization tries to do some good in whatever centers that they're in. We had all kinds of programs, and this was just one aspect of our educational program in taking children to different places to see things. . . . Goodwill Homes was a social organization and community building in South Memphis. They took in students . . . and they would help them. . . . I can remember how many steps we'd have to climb to get to the top balcony [when Ellis Auditorium] was segregated.

Alma Roulhac Booth, interview with Marina Pacini, Wyncote, PA, 11 October 2007.

HOUSE OF HAPPINESS
—Bert Ferguson,
executive vice president
and general manager of
WDIA Radio Station,
2074 Union Avenue,
proudly stands beside
a building made of
candy—which represents
Keel Avenue School for
Handicapped Children—
made by students at the
school and presented to
Mr. Ferguson at WDIA's
recent Christmas party
at the school. WDIA
provides buses and
drivers which take the
students to and from
their studies, daily.

Memphis World,
5 January 1963, 3.
Photograph by
Mark Stansbury.
2006.31.122

Bert Ferguson, co-owner of WDIA, was instrumental in forming the first radio programs targeting and dealing with issues relevant to African American audiences in Memphis. Under his leadership, the radio station actively participated in the community, providing assistance to those in need. Keel Avenue School was a recipient of such support. Founded in the mid-1950s, the school provided a public learning environment for handicapped black children in which they would have the chance to learn and socialize with others—something that previously had been denied them. One of the main problems facing the students was a lack of transportation to and from school. WDIA provided buses. The radio station also planned entertainment for the students, such as the annual Christmas party.

In the photograph, Ferguson stands proudly next to a miniature cardboard building adorned with colorful hard candies in wrappers. He rests his left hand on top of the festive structure—a small but telling detail. This simple fact signifies Ferguson's connection and commitment to the school and, more broadly, to the African American community.
KD

COMMUNITY VOICES

Talk had been going on about opening up a school for black crippled children. At that time, the Shriners provided the transportation for white students to go to Shrine School, but black students were served at home. So they didn't have any transportation. WDIA furnished the first transportation to pick up these children and take them to school. . . . They got in touch with me at Hamilton School and asked me to come in. During the summer, I interviewed these kids to get ready to come to school in September. Mr. Brooks and Brother Wade were the bus drivers that picked up these children every day and brought them back and forth to school. This went on from '55 to '65 or '70. By that time, integration had come and we built a new school—Shrine School for Crippled Children—and it was integrated there. . . . Bert Ferguson was a very cordial man. He insisted that his staff came every year to our Christmas party. WDIA not only furnished the buses, but they furnished the Christmas. They bought toys for the children and we had a Christmas program. The whole WDIA staff came over and I thought that that was so wonderful and professional. . . .

Alma Roulhac Booth, interview with Marina Pacini, Wyncote, PA, 11 October 2007.

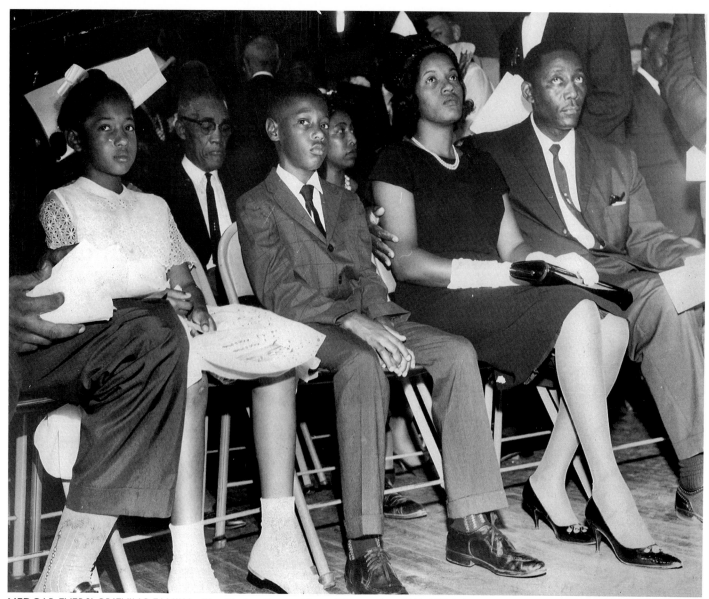

MEDGAR EVERS' GRIEVING FAMILY—Mrs. Medgar Evers, widow of the murdered NAACP field secretary in Mississippi, is shown with two of her three children and her brother-in-law during funeral rites for her husband at the Masonic Temple in Jackson. Left to right: Rena Denise Evers, Darrell Kenyatta Evers, Mrs. Evers, and Charles Evers of Chicago who has taken over his brother's NAACP post temporarily. Mrs. Evers appeared on the verge of breaking down only once and that was when the crowd of 4000 sang her husband's favorite song, "We Shall Overcome."

Memphis World, 22 June 1963, 1.
Photograph by Mark Stansbury.
2006.31.119

Medgar Evers was a noted civil rights activist. Denied admission to the University of Mississippi Law School in 1954, he played an instrumental role in James Meredith's acceptance to Ole Miss in 1962. Evers was NAACP field secretary in Jackson, Mississippi, and his campaign for racial equality led to his murder on 12 June 1963. After returning from a meeting about integration, he was shot in front of his home by Ku Klux Klan member Byron De La Beckwith.

The photograph of Evers's grieving family resembles those taken at the funerals of other American leaders such as Rev. Martin Luther King Jr. and President John F. Kennedy. The widowed wife remains stoic and strong for her young children, while a male family member provides support. Myrlie Evers continued her husband's legacy as a civil rights activist and eventually became the first woman to serve as chairman of the National Board of Directors of the NAACP—a post she held from 1995 to 1998. Ultimately, the photograph is a reminder of the loss borne by some families during one of the most turbulent times in U. S. history.
KD

COMMUNITY VOICES

I was at Medgar's funeral. Jet Magazine sent me down and I had the Week's Best Photo. . . . [I]t was at the Masonic Lodge down on Jackson Street, as I can remember. It was real tense because Byron De La Beckwith, as I can recall, had shot Medgar that night. Maxine Smith was the last person to see him alive. . . . I remember all downtown Jackson was closed because of the marches and the funeral cortege went through downtown. Tensions were high because you had a lot of African Americans—kind of like Jena was last week. Ernest Withers was there. The police arrested him and put him in the trucks that they had that they would take you to jail in. . . . I can recall they took the protestors out to the stockyard—that's where they were booking them—they kind of roughed Ernest up and they exposed two or three rolls of his film.

Mark Stansbury, interview with Marina Pacini, Memphis, TN, 26 September 2007.

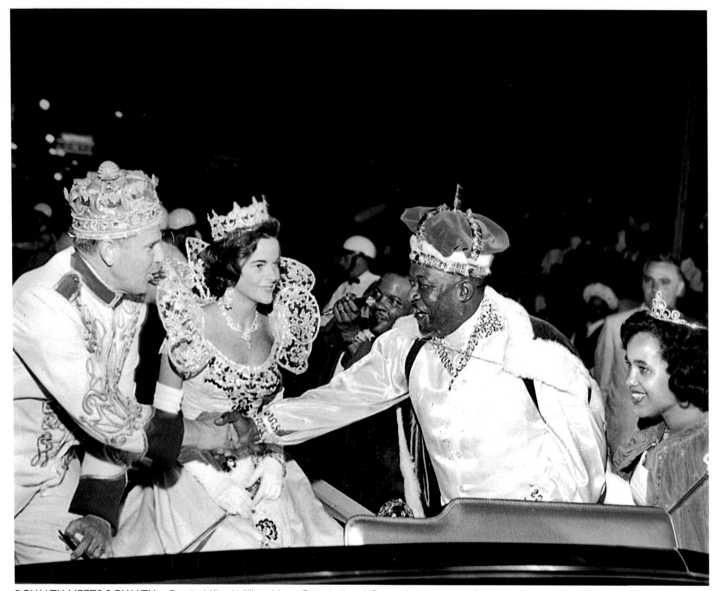

ROYALTY MEETS ROYALTY—Carnival King William Mann Campbell and Queen Marie Louise Crump at left, were given a police escort to Beale Street Friday night to meet and greet Memphis Cotton Makers' Jubilee King Elias Williams and Queen Nadine Poindexter. Miss Poindexter flew back to Pittsburgh Sunday morning to resume her duties with the Pittsburgh Housing Authority and continue studies at the University of Pittsburgh.

Memphis World, 23 May 1964, 3.
2006.31.103

In 1964 Memphis had two kings and queens of cotton. The royalty of the Memphis Cotton Carnival consisted of William Mann Campbell, president of the First National Bank of Eastern Arkansas, and Marie Louise Crump, a junior at Memphis State University (today the University of Memphis) and the third Crump to serve as queen by 1964. Her father, Frank Crump Jr., was the 1960 Carnival president. The Memphis Cotton Makers' Jubilee royalty consisted of Nadine Poindexter, a student from the University of Pittsburgh, and Elias Williams, a community leader and local funeral home director.

A similar photograph of the meeting can be found in the *Memphis Press-Scimitar*, the predominately white evening paper. Shot from behind Williams and Poindexter, the photograph blocks out their faces and focuses instead on Campbell and Crump, who occupy the center of the image. White press documenting the Cotton Carnival oftentimes emphasized the queen, who embodied a romanticized perspective of southern femininity. Within the *Memphis World's* photograph, however, the composition is balanced between the couples, conveying equality through layout. If the foreground of "Royalty Meets Royalty" can be read as staged optimism, the background is a reminder of the ever present conflict and violence of the period, as policemen are seen controlling the crowds.
BJ

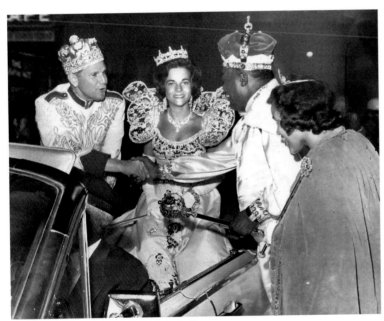

Memphis Press-Scimitar, 16 May 1964, 12.

Detective Turner Now a Lieutenant (When he walked a beat)

Memphis World,
29 August 1964, 1.
Photograph by
Ernest C. Withers.
RS2006.2.51

Also published:
Memphis World,
20 July 1957, 1;
Memphis World,
10 September 1960, 1.

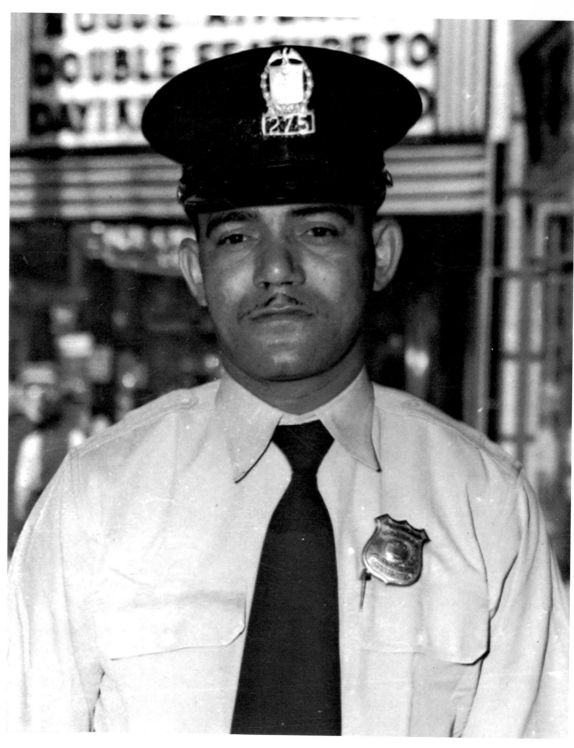

Reproduced several times in the *Memphis World*, this photograph of Rufus J. Turner provided a familiar face for stories about the experiences of one of the city's first black policemen. He joined the force in 1948 with eight other African Americans, the same year President Harry Truman ended segregation in the U. S. Armed Forces and white southerners formed the States' Rights Democratic Party with Strom Thurmond as its nominee for president. In Memphis, several incidents of police brutality and murder impelled community leaders to demand the appointment of black officers. When Turner retired in 1982, he held the rank of captain. His thirty-four-year tenure was the longest of the original nine. He was among the first to be promoted to sergeant, in 1950; he made detective in 1960; and through that turbulent decade he successfully pushed for the establishment of police community relations centers, the first of which opened in 1967. The following year he was appointed director of the Community Relations Program.

Before it was cropped heavily, this photograph captured Turner and a fellow officer standing on Beale Street. In its current state the image focuses narrowly on Turner framed against the backdrop of the Palace Theatre marquee. The placement provides a perhaps ironic contrast between the spectacle of Hollywood entertainment and escapism and the far more mundane, but pressing, affairs of keeping the peace. Though Beale could be a difficult assignment, especially as the first black officers could not carry weapons or arrest whites, Turner's body, frontal and centered, as well as his steady gaze, makes him a bedrock presence in an otherwise busy locale. DMcC

COMMUNITY VOICES

They were called "degrading" names by the public and even their commanding officers forced them to stand roll call out in an open field in winter, often waiting for hours for their commanders to show and forbidden to leave, some of the men said.

"There were times when I felt I just couldn't take it any more and wanted to quit. I believe the only reason I stuck it out was because I wanted to prove they couldn't run me off," said Lt. R.J. Turner, one of the three survivors of that first group.

Menno Duerksen, "Abused at First, Negro Policemen Now in Demand, Greatly Respected," *Memphis Press-Scimitar*, 14 February 1969, 11.

BIBLIOGRAPHY

Archives

Crossroads to Freedom Digital Archive, Rhodes College, Memphis, TN. www.crossroadstofreedom.org.

Memphis and Shelby County Room, Benjamin Hooks Library, Memphis, TN.

Special Collections, Ned R. McWherter Library, University of Memphis, Memphis, TN.

Oral Histories

The following interviews were conducted for the catalogue and exhibition, and are in the collection and project files at the Memphis Brooks Museum of Art.

Alma Roulhac Booth, 11 October 2007
Josephine Bridges, 6 October 2007
Longino Cooke, 23 October 2007
Justin Ford, 7 December 2007
Francine Guy, 3 July 2008
Burnell Hurt, 19 September 2007
H.T. Lockard, 16 April 2008, 25 April 2008
Earline Nelson, 24 April 2008
Joseph Nelson, 18 April 2008
Rashad Sharif, 19 January 2008
Mark Stansbury, 26 September 2007
Russell Sugarmon, 14 March 2008
Katheryn Perry Thomas, 28 November 2007
Emogene Watkins Wilson, 11 December 2007
David Wright, 18 December 2007

Publications

AFL-CIO. Industrial Union Department. *Tent City: Home of the Brave,* Washington, D.C.: 1961.

Barlow, William. *Voice Over: The Making of Black Radio.* Philadelphia: Temple University Press, 1999.

Barthes, Roland. *Camera Lucida: Reflections on Photography.* Translated by Richard Howard. New York: Hill and Wang, 1981.

———. *The Responsibility of Forms: Critical Essays on Music, Art, and Representation.* Translated by Richard Howard. New York: Hill and Wang, 1985.

Benjamin, Walter. *One-Way Street and Other Writings.* Translated by Edmund Jephcott and Kingsley Shorter. New York: Verso, 1997.

———. *Reflections: Essays, Aphorisms, Autobiographical Writings.* Translated by Edmund Jephcott. New York: Schocken Books, 1986.

Bond, Beverly G., and Janann Sherman. *Memphis in Black and White.* Charleston, SC: Arcadia Publishing, 2003.

Bourdieu, Pierre. *Photography: A Middle-Brow Art.* Translated by Shaun Whiteside. Stanford: Stanford University Press, 1990.

Clarke, Graham. *The Photograph.* New York: Oxford University Press, 1997.
Graham, Lawrence Otis. "Black Elite in Memphis." In *Our Kind*

of People: Inside America's Black Upper Class, 272-293. New York: HarperCollins, 1999.

Green, Laurie B. Battling the Plantation Mentality: Memphis and the Black Freedom Struggle. Chapel Hill: University of North Carolina Press, 2007.

Gruber, J. Richard. Memphis: 1948-1958. Memphis: Memphis Brooks Museum of Art, 1986.

hooks, bell. Art on My Mind: Visual Politics. New York: New Press, 1995.

Melton, Gloria Brown. "Blacks in Memphis, Tennessee, 1920-1955: A Historical Study." Ph.D. diss., Washington State University, 1982.

Mitchell, W.J.T. "Representation." In Critical Terms for Literary Study, edited by Frank Lentricchia and Thomas McLaughlin, 11-22. Chicago: University of Chicago Press, 1990.

Orvell, Miles. American Photography. New York: Oxford University Press, 2003.

Rosler, Martha. "In, Around, and Afterthoughts (On Documentary Photography)." In Decoys and Disruptions: Selected Writings, 1975-2001, 151-206. New York: MIT Press in association with International Center of Photography, 2004.

Self, Joann. Producer and director, The WLOK Story. Memphis: Gilliam Foundation, 2002.

Shannon, Samuel. "Tennessee." In The Black Press in the South, 1865-1979, edited by Henry Lewis Suggs, 313-355. Westport, CT: Greenwood Press, 1983.

Solomon-Godeau, Abigail. Photography at the Dock: Essays on Photographic History, Institutions, and Practices. Minneapolis: University of Minnesota Press, 1991.

Sontag, Susan. On Photography. New York: Farrar, Straus and Giroux, 1977.

Southern Eye, Southern Mind: A Photographic Inquiry. Memphis: Memphis Academy of the Arts, 1981.

Tagg, John. "A Democracy of the Image: Photographic Portraiture and Commodity Production." In The Burden of Representation: Essays on Photographies and Histories, 34-65. Amherst: University of Massachusetts Press, 1988.

The Tennessee Encyclopedia of History and Culture. tennesseeencyclopedia.net.

Trachtenberg, Alan. Reading American Photographs: Images as History, Mathew Brady to Walker Evans. New York: Hill and Wang, 1989.

Turner, Allegra W. Except by Grace: The Life of Jesse H. Turner. Jonesboro, AR: FOUR-G Publishers, 2004.

Willis, Deborah, ed. Picturing Us: African American Identity in Photography. New York: New Press, 1996.

———. Reflections in Black: A History of Black Photographers 1840 to the Present. New York: W.W. Norton and Company, 2002.

Wilson, Charles Reagan, and William Ferris, eds. Encyclopedia of Southern Culture. Chapel Hill: University of North Carolina Press, 1989.

Periodicals
Commercial Appeal
Memphis Press-Scimitar
Memphis World
Tri-State Defender